Klimt

Grange
BOOKS

Author: Jane Rogoyska and Patrick Bade

Designed by
Baseline Co Ltd
19-25 Nguyen Hue, District 1
Ho Chi Minh City, Vietnam

© 2005 Sirrocco, London, UK (English version)
© 2005 Confidential Concepts, worldwide, USA

Published in 2005 by Grange Books
an imprint of Grange Book Plc
The Grange Kingsnorth Industrial Estate
Hoo, nr Rochester, Kent ME3 9ND
www.Grangebooks.co.uk

ISBN 1-84013-781-9

Printed in Singapore

Contents

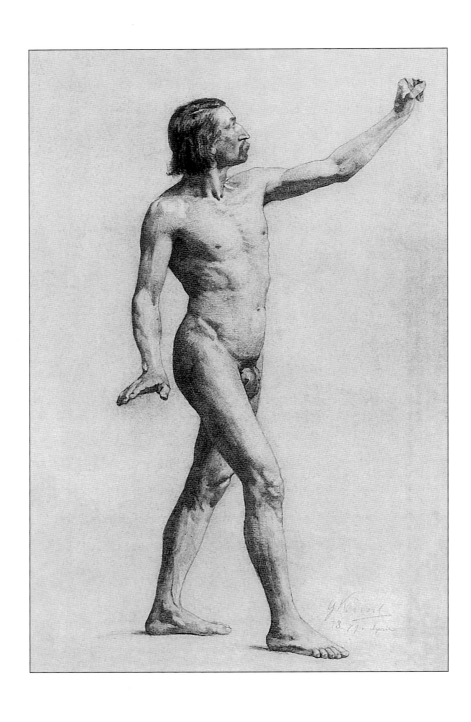

4.

His Life

"I am not interested in myself as a subject for painting, but in others, particularly women..."

Beautiful, sensuous and above all erotic, Gustav Klimt's paintings speak of a world of opulence and leisure, which seems eons away from the harsh, post-modern environment we live in now. The subjects he treats – allegories, portraits, landscapes and erotic figures – contain virtually no reference to external events, but strive rather to create a world where beauty, above everything else, is dominant.

His use of colour and pattern, profoundly influenced by the art of Japan, ancient Egypt, and Byzantine Ravenna, the flat, two-dimensional perspective of his paintings, and the frequently stylized quality of his images form an œuvre imbued with a profound sensuality and one where the figure of woman, above all, reigns supreme.

Beginnings

Klimt's very first works brought him success at an unusually early age. He came from a poor family where his father, a goldsmith and engraver, could scarcely support his wife and family of seven children. Gustav, born in 1862, obtained a state grant to study at the *Kunstgewerbeschule* (the Vienna School of Art) at the age of 14. His talents as a draughtsman and painter were quickly noticed, and in 1879 he formed the *Künstlerkompagnie* (Artists' Company) with his brother Ernst and another student, Franz Matsch.

The latter part of the nineteenth century was a period of great architectural activity in Vienna. In 1857, the Emperor Franz Joseph had ordered the destruction of the fortifications that had surrounded the medieval city centre. The Ringstrasse was the result, a budding new district with magnificent buildings and beautiful parks, all paid for by public expenses. This meant therefore, that the young Klimt and his partners had ample opportunities to show their talents and they received early commissions to contribute to the decorations for the pageant organized to celebrate the silver wedding of the Emperor Franz Joseph and the Empress Elisabeth. In the following year, they were commissioned to produce a ceiling painting for the Thermal Baths in Carlsbad. Other public commissions soon followed.

When one examines his early works, such as *Fable* (p.55), *Idyll* (p.57), or indeed one of Klimt's earliest drawings, *Male Nude Walking Facing Right* (p.4), it is clear that he is a painter of great skill and promise, but remains entirely within the accepted contemporary norms in his depiction of academic and allegorical subjects. The women depicted in *Fable* and *Idyll* are plump, adroitly draped in plain clothing, their hair smoothly pulled back behind the neck. Neither would look out of place in the eighteenth or even seventeenth century. Their sensuality is matronly, motherly, their nudity decorous rather than exciting.

In the past, pubic hair had – if this part of the body was revealed at all – traditionally been glossed over into a smooth and non-threatening 'v' reminiscent of modern-day children's dolls. Many early medieval or Renaissance paintings which had shown even the suggestion of male or female genitalia had suffered the absurd addition of a floating fig leaf painted in by later, more prudish, types. But even as early as 1896, Klimt had begun to be more explicit in the way he chose to depict the human figure.

1. *Male Nude Walking Facing Right*,
 1877-79
 pencil, 43 x 24 cm.

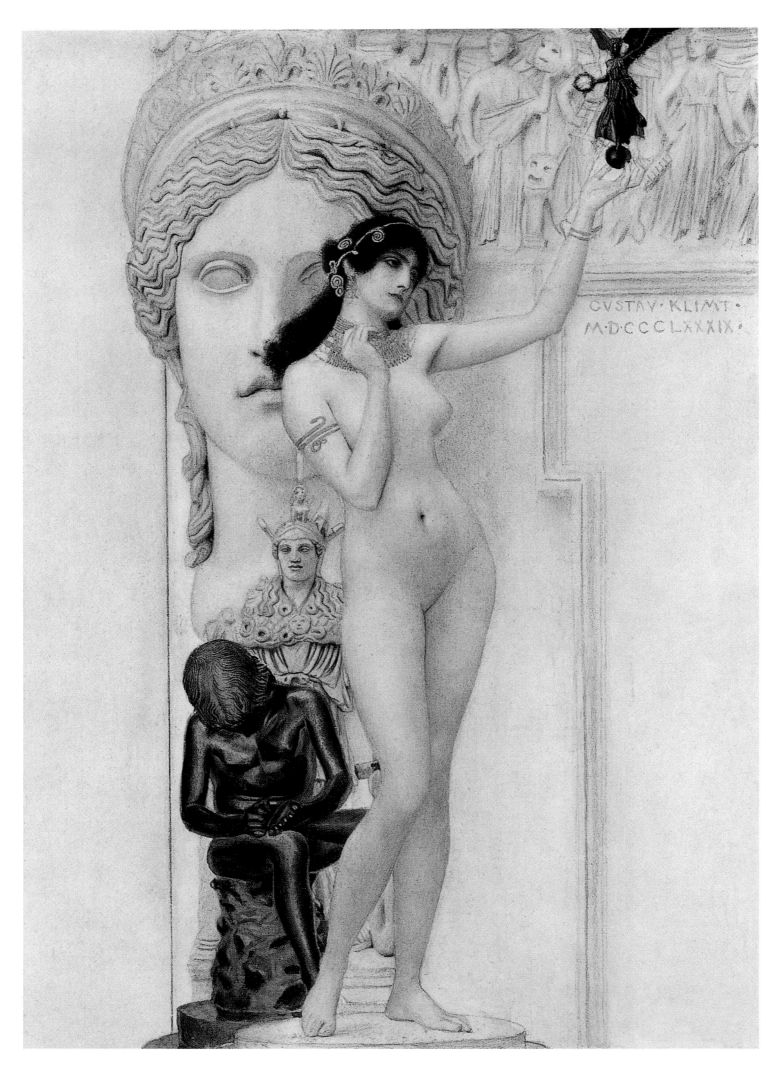

6.

2. *Allegory of "Sculpture"*, 1889.
 pencil and watercolour,
 44 x 30 cm,
 Historisches Museum, Vienna.

3. *Fairy Tale*, 1884
 black pencil, ink and lavish,
 63.9 x 34.3 cm,
 Historisches Museum, Vienna.

4. *The Death of Juliet*, 1886
 black pencil with white
 highlights, 27.6 x 42.4 cm,
 Graphische Sammlung
 Albertina, Vienna.

5. *Man's Head Lying Down*, (Painting
from the ceiling of The Imperial
Venetian Theatre), 1886-1888
black chalk, white highlights,
28 x 43 cm,
Graphische Sammlung
Albertina, Vienna.

There is, for example, an interesting difference between the final drawing for Sculpture and the painting itself. In the drawing we already see the trademark loose, wild, dark hair and the faintest traces of pubic hair. The woman gazes directly at the viewer, standing as if caught naked in her bedroom doorway, summoning the viewer to caress her. The painting, by contrast, has reverted to a more traditional style: gone is the frontal stance, with the reappearance of the classical sculptural pose. Up goes the hair and the pubic hair disappears.

Secession

These early commissions established Klimt as a successful and prominent artist. Following the death of his father and brother Ernst in 1892, there seems to have been a distinct cooling-off in the working relationship between Klimt and Matsch as Klimt began to explore more adventurous subjects.

In 1894, Matsch moved out of their shared studio, and in 1897 Klimt, together with his closest friends, resigned from the *Künstlerhausgenossenschaft* (the Co-operative Society of Austrian Artists) to form a new movement known as the Secession, of which he was immediately elected president.

The Secession was a great success, holding both a first and a second exhibition in 1898. The movement made enough money to commission their very own building, designed for them by the architect Joseph Maria Olbrich. Above the entrance was their motto: "To each age its art, to art its freedom". The Secession not only came to represent the best of Austrian art, but was also successful in the bringing together of Viennese-French Impressionist and Belgian Naturalist works, which had never before been seen by the Austrian public.

Klimt was undoubtedly the central figure in this young and dynamic movement, but his success as a modern artist went hand in hand with the loss of his status as an accepted and established painter.

As he moved away from his traditional beginnings, he soon found himself at the centre of a series of scandals, which were to change his entire career.

Scandal

In 1894, Klimt and Matsch had received a commission to produce a series of paintings for the University of Vienna. The subjects Klimt was assigned were Philosophy, Medicine, and Jurisprudence. The nature of the commission can easily be imagined: the university would be expecting a series of dignified, formal paintings in classical style depicting the wisdom of philosophers, the healing virtues of medicine, and doubtless a statuesque blindfolded female figure holding a pair of scales and representing justice.

What they got, several years and much hard work later, caused such a scandal that Klimt eventually repaid the advances he had received and took the paintings back.

Despite the fact that on its first showing in Paris at the World Fair in 1900 *Philosophy* won him the gold medal, the Viennese were not of the same opinion as the French as to the painting's merits.

6. *Portrait of a Woman,* c. 1894 oil on wood, 39 x 23 cm, Kunsthistorisches Museum, Vienna.

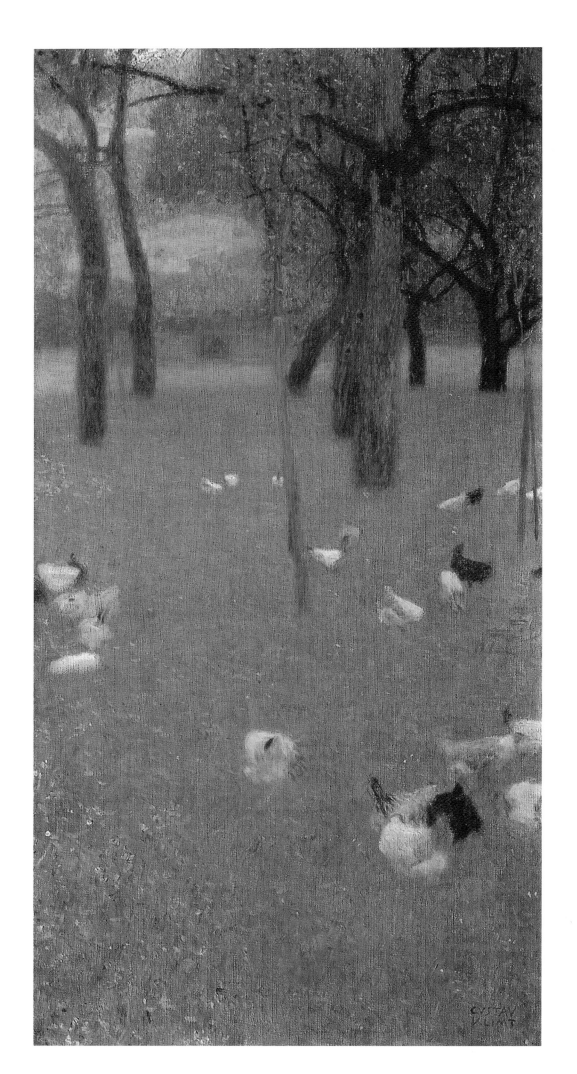

7. *After the Rain*, 1899
 oil on canvas, 80 x 40 cm,
 Österreichische Galerie, Vienna.

8. *Water Sprites (Silver Fishes)*, 1899
 oil on canvas, 82 x 52 cm,
 Kunstsammlung Bank Austria
 AG, Vienna.

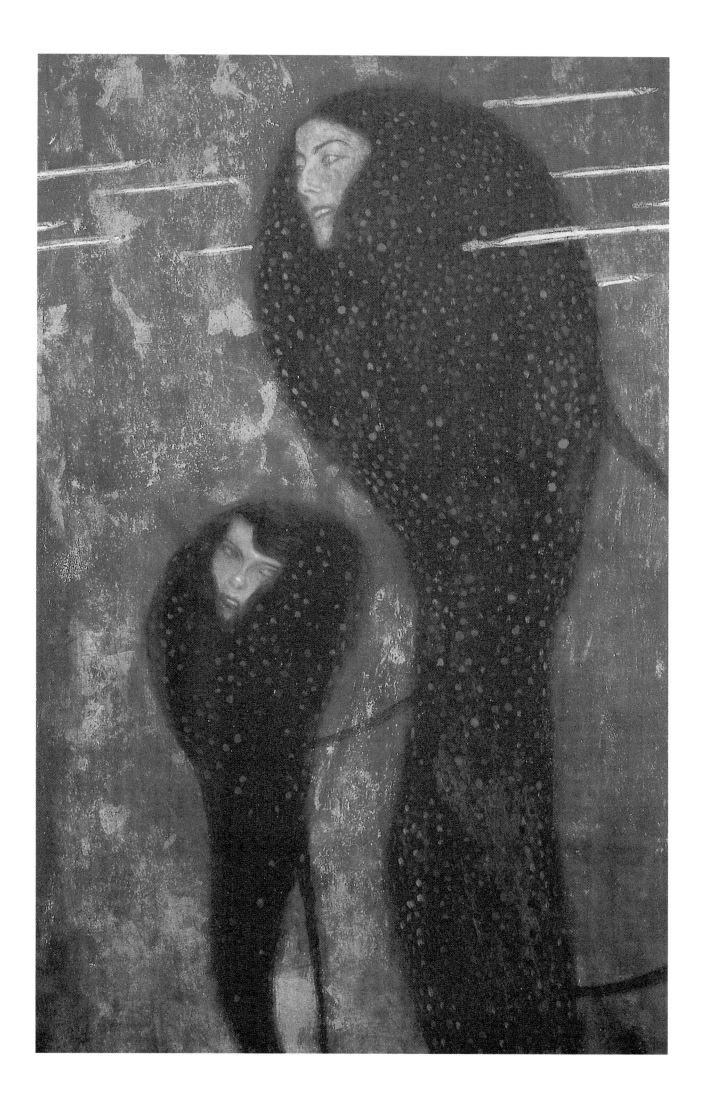

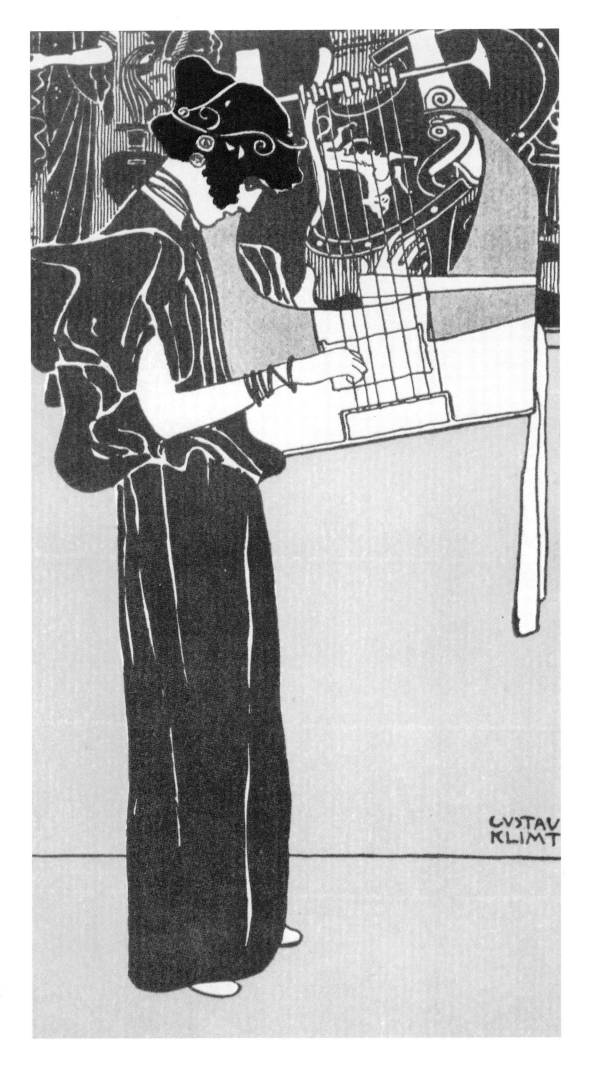

9. *Music*, 1901
 lithography.

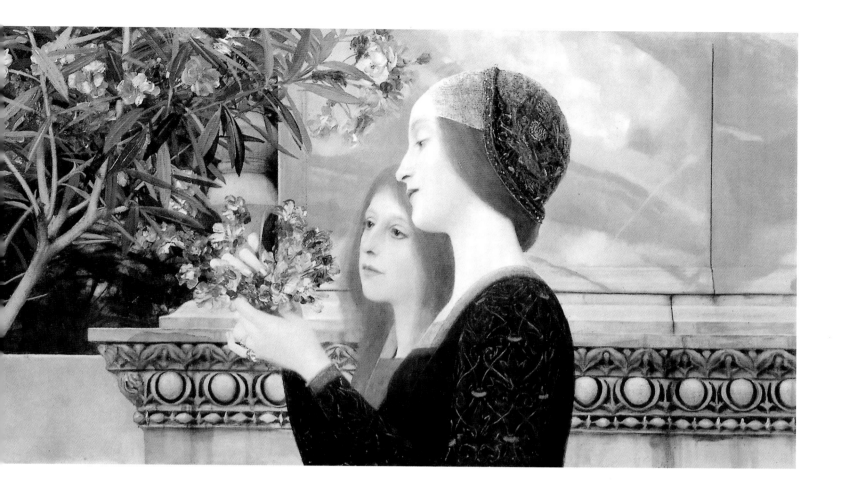

The first appearance of the unfinished Medicine in the following year caused even greater controversy. It is difficult to fathom precisely what Klimt meant to say about medicine in this painting.

The vision is chaotic, almost hellish. Its skulls, wrinkled elderly figures and mass of human bodies speak of human suffering, not of its cure. The viewer's eyes are drawn inevitably to the two striking female figures at the bottom and top left of the painting. Clearly the figure at the bottom represents Medicine itself as the traditional symbol of the serpent suggests, but rather this art nouveau woman, adorned in gold, looks more like a priestess likely to sacrifice a sick person than to heal them. The naked woman at the top of the picture is remarkable for the dynamic abandonment of her pose. Our eyes are inevitably drawn to the woman's groin as she flings out her arms in a parody of crucifixion.

The sketch for the figure shows very clearly how bold and excellent a craftsman Klimt was: the heavy line and subtle shading lead our eyes firmly to the woman's pubic hair. Interestingly though, in the sketch the woman looks as if she may have posed lying down or leaning against something, whereas in the painting she is standing precariously unsupported, as if about to fall.

10. *Two Girls with Oleander*, 1890 oil on canvas, 55 x 128.5 cm, Wadsworth Atheneum, Hartford (Connecticut).

Both these and the other female figures around them represent a complete departure from the rotund, comfortable women of the traditional nineteenth-century academic style. Klimt's women are long-haired, slender, lithe, and possess a sexual awareness that is both alluring and almost threatening in its directness.

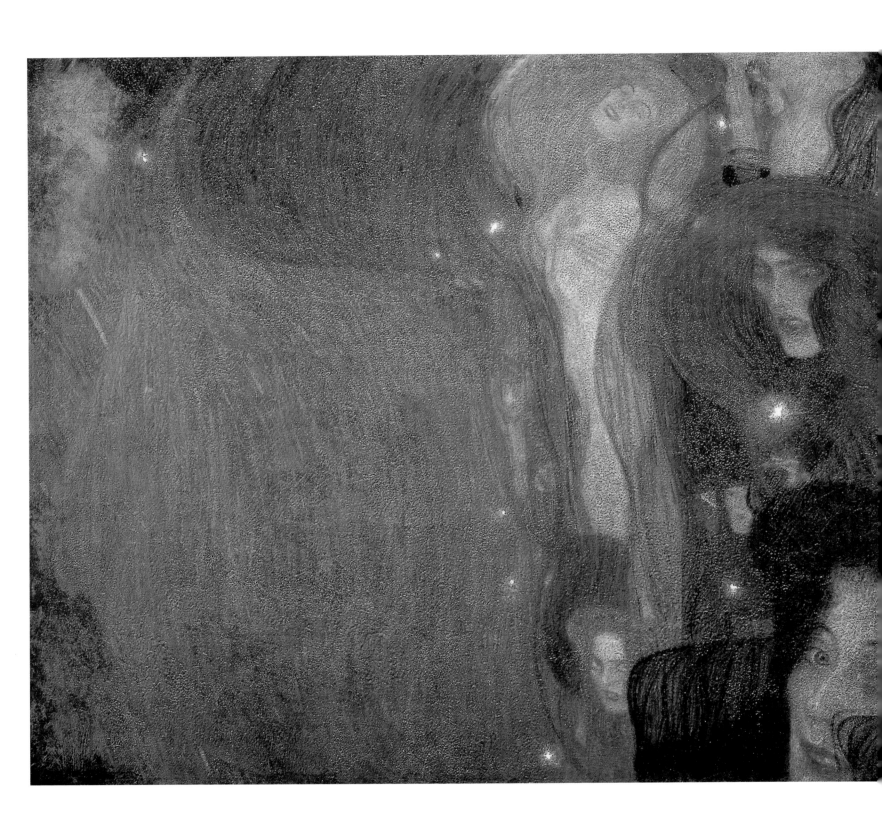

11. *Will-o'-the-Wisp,* 1903
oil on canvas, 52 x 60 cm,
private collection.

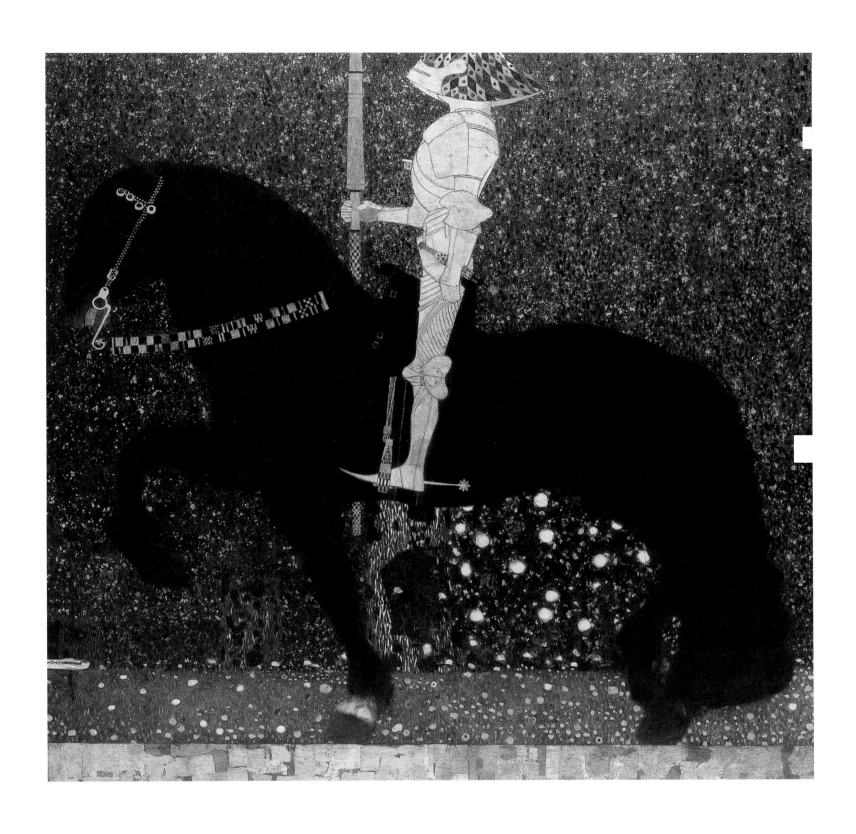

12. *The Golden Knight*, 1903
oil, tempera and gold on
canvas, 103.5 x 103.7 cm,
Aichi Prefectural Museum of
Art, Nagoya, Japan.

Klimt's contemporary Berta Zuckerkandl makes the following comment in her memoirs: "Klimt had created from Viennese women an ideal female type: modern, with a boyish figure."

They had a mysterious fascination; although the word 'vamp' was still unknown he drew women with the allure of a Greta Garbo or a Marlene Dietrich long before they actually existed." *(Ich erlebte fünfzig Jahre Weltgeschichte (I witnessed fifty years of world history),* Stockholm 1939.) Looking at his 1909 portrait *Woman with a Hat and feather Boa* (p.127) it is easy to see the truth of this statement. The woman's face, half-hidden by feathers and a hat, looks not unlike a dark-haired version of Marilyn Monroe. The seductively half-closed eyes certainly echo many Monroe poses.

The Secession's fourteenth exhibition in 1902 led to yet another scandal. The exhibition centred around Max Klinger's statue of Beethoven. Klimt had decided to contribute a frieze. The detail shown depicts *The Envy, The Luxury and The Excess* (p.24-25), three allegorical figures designed to occupy part of the central wall of the room where Klinger's statue was to be exhibited. Again, Klimt's reason for choosing precisely these subjects for a tribute to Beethoven remains obscure, but they contain the seeds of many later works, most notably the trademark use of exotically patterned textiles to form not so much a backdrop to the human figures, but to create a composition of which pattern and human figure are equal parts.

In the figure of Envy, shown top left, Klimt uses the woman's hair both to hide her sex and to draw attention to it. The superb figure of Excess resembles not so much a woman as an oriental *pasha*, a man whose corpulence has reached such an extent that his chest has expanded to form female breasts.

13. *Woman near the Fire,* 1897-1898
 oil on canvas, 41 x 66 cm,
 Österreichische Galerie,
 Vienna.

14. *Portrait of a Woman,* 1897
 pastel on velin paper,
 51.2 x 27.7 cm,
 Allen Memorial Art Museum,
 Oberlin, Ohio.

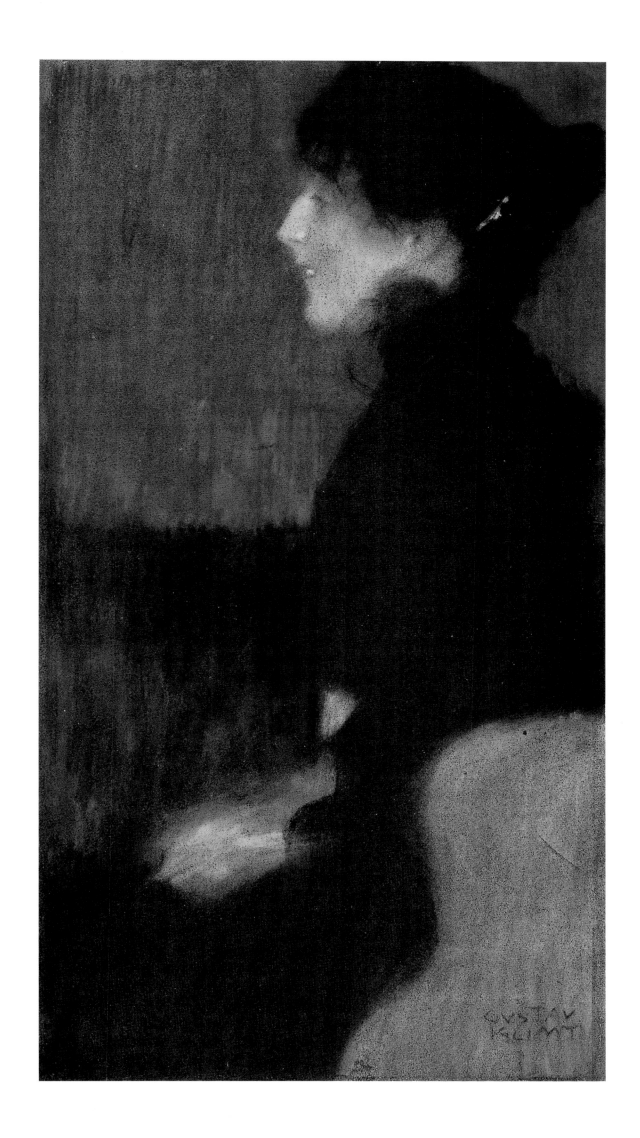

19.

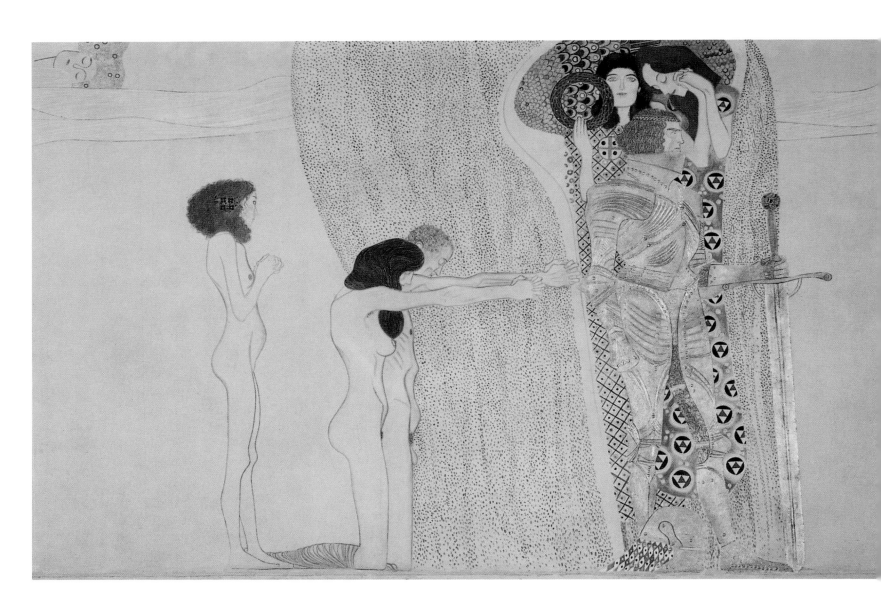

15. *The Beethoven-Frieze* (Left panel),
1902.
casein on plaster, H. 220 cm,
Secession, Vienna.

16. *The Beethoven-Frieze* (Detail,
centre panel), 1902.
casein on plaster, H. 220 cm,
Secession, Vienna.

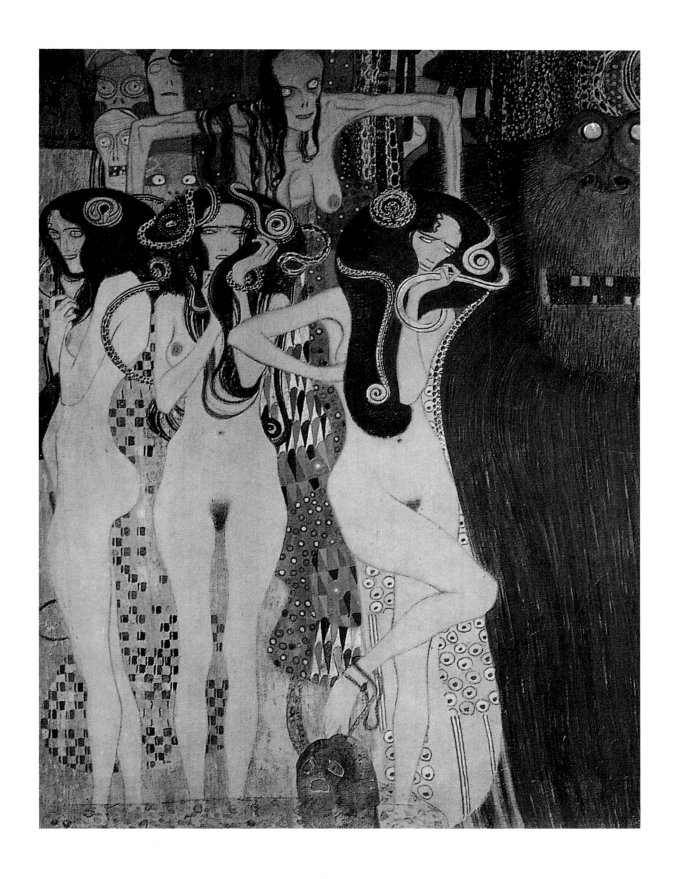

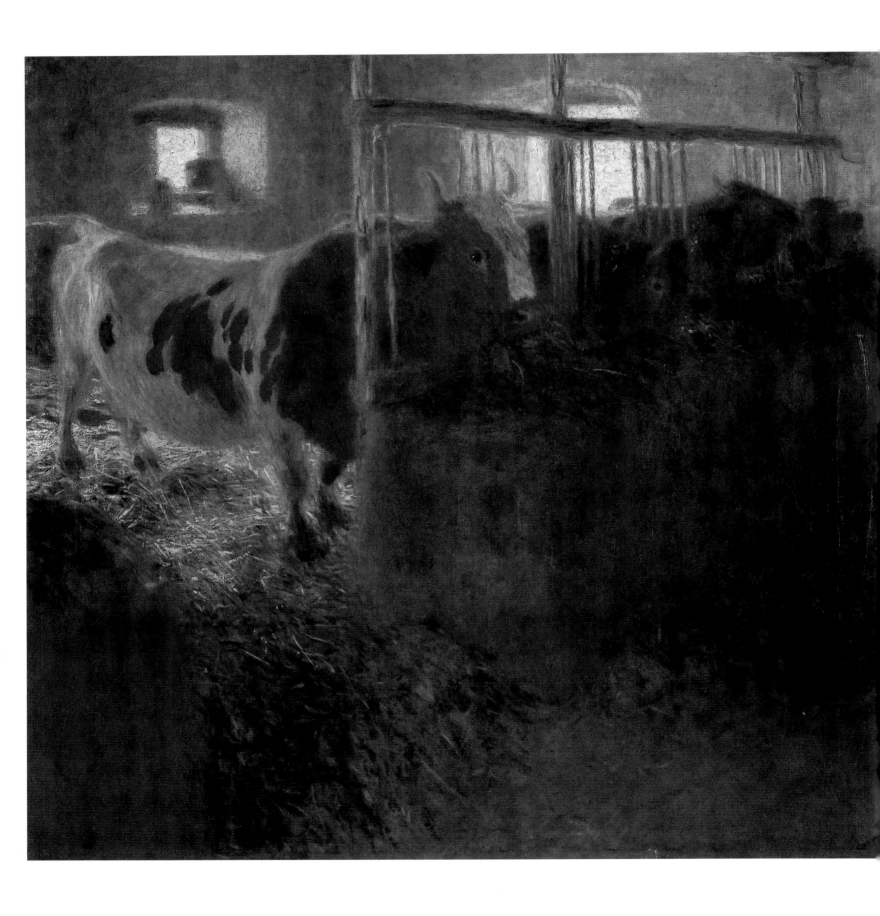

Conservative Viennese society was once again profoundly shocked by these images, much in the same way that modern-day exhibition-goers are shocked by a Damien Hirst. Klimt's contemporary Felix Salten relates: "Suddenly an exclamation came from the centre of the room: 'Hideous!' An aristocrat, a patron and collector, whom the Secession had let in today together with other close friends, had lost his temper at the sight of the Klimt frescoes. He shouted the word in a high, shrill, sharp voice... he threw it up the walls like a stone. 'Hideous!'"

Klimt's only response to this, as he worked away on the scaffolding above, was an amused glance in the direction of the departed man. This calm response perhaps best typifies Klimt's reaction to the scandals he caused.

Although the faculty paintings ensured that Klimt swiftly lost the patronage of the Emperor and other establishment figures, he was fortunate enough to be able to earn an extremely comfortable living from painting portraits and thus did not have to worry about this loss. Three times, however, he was refused a professorship of the Academy. Only in 1917 was he offered the small consolation of being made an honorary member.

Fin de siècle Vienna

It must be remembered that despite their tastes for balls, the opera, theatre and music, the Viennese upper classes were extremely conservative in their tastes. A combination of strict Roman Catholicism and rigid social morale mores kept them buttoned up, at least on the surface. And whilst people were only too happy to indulge in all sorts of sensual pleasures that were sanctioned by society – the waltz, for example – they did not appreciate having openly erotic, ugly or sexual subjects thrust before them, a double standard which speaks volumes about the fin de siècle morality.

The Vienna into which Klimt was born was a city perched uncomfortably on the cusp of two eras. Then, it was still the capital of a far-reaching empire of over fifty million inhabitants, ruled by the Emperor Franz Joseph.

However, by the time of Klimt's death in 1918, the Habsburg Empire itself had only seven months left to live. Austria then became a tiny nation state of seven million inhabitants, three million of whom were concentrated around Vienna. Twenty years later it was absorbed by Nazi Germany under the leadership of Adolf Hitler, himself, ironically, born on Austrian soil.

The period of decline had begun even before Klimt was born. Military defeats across the Empire sounded warning bells for future stability, whilst Vienna was filling up with Czechs, Gypsies, Hungarians, Poles, Jews, and Rumanians – immigrants from the poorest parts of the Empire, all in search of work, often living in appalling conditions. The wealthy Viennese, however, chose not to acknowledge these signals of future trouble but rather to ignore the outside world and immerse themselves in a whirl of pleasurable activities.

17. *Cowshed*, 1899
oil on canvas,
Neue Galerie der Stadt Linz,
Austria.

This was a period of great musicians – Brahms, Bruckner, Strauss the younger, Schönberg, Mahler and, of course, Franz Lehár, creator of the light operettas so beloved of the Viennese. It was also the era of Sigmund Freud, Alfred Adler, Arthur Schnitzler, and amidst all this, Klimt.

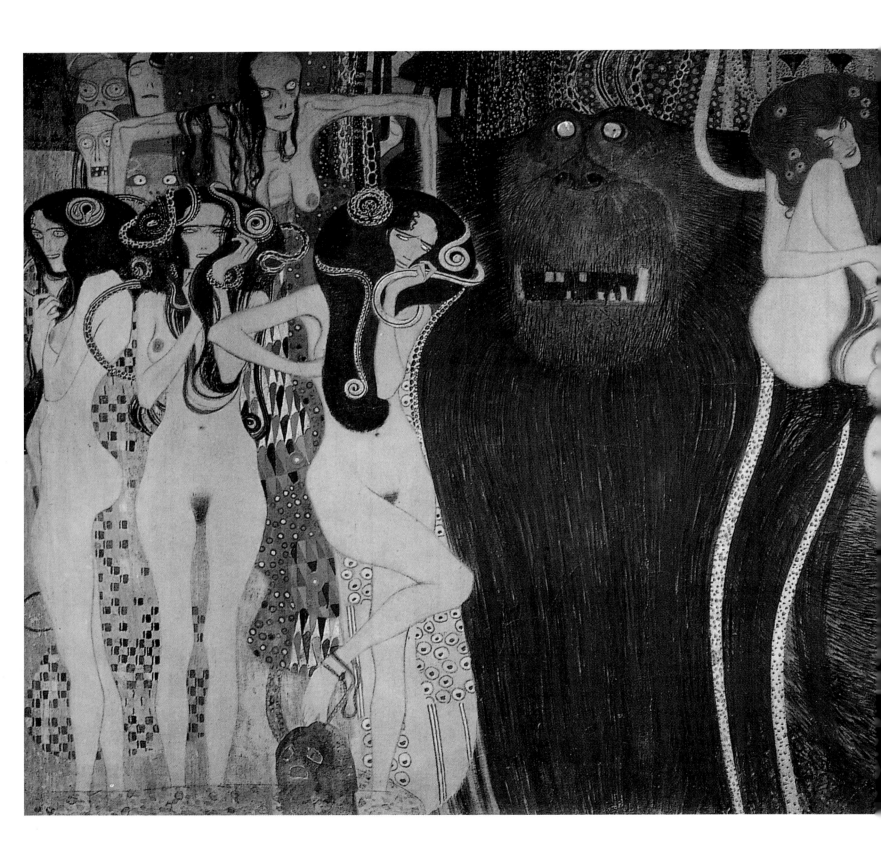

24.

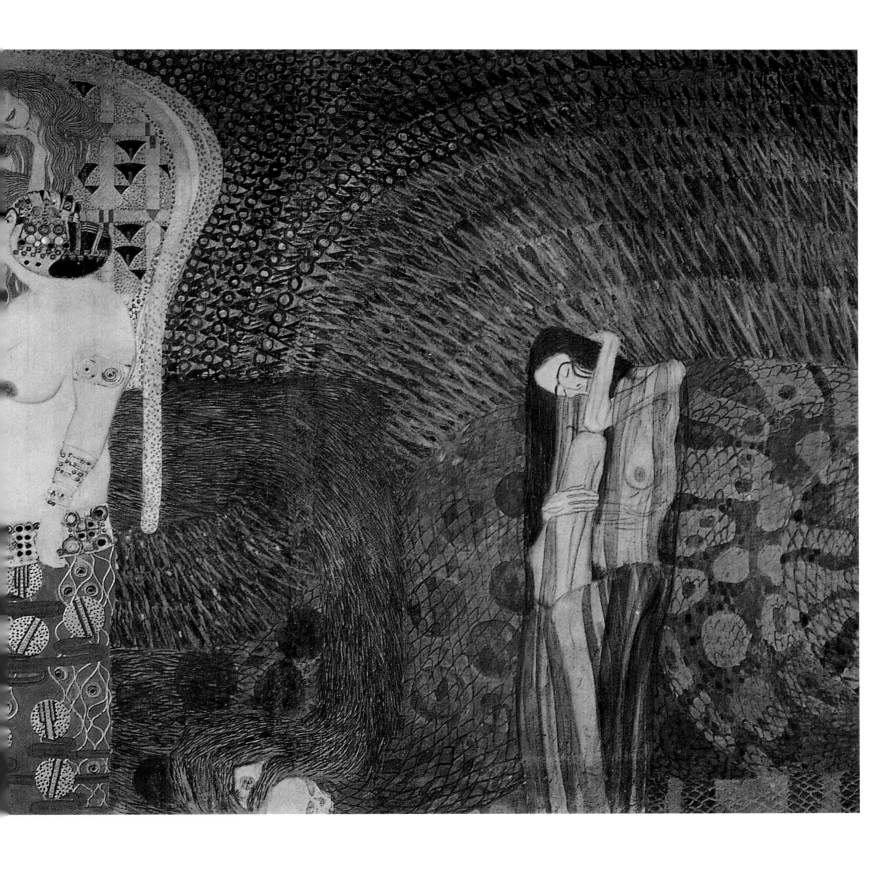

18. *The Beethoven-Frieze*
 (Middle panel), 1902
 casein on plaster, H. 220 cm,
 Secession, Vienna.

Lovers and Friends

One of the most tantalising facts about a man so well-known in times comparatively recent to our own is that almost nothing concrete is known about Klimt's personal life, a fact largely due to his own reticence on the subject. Whilst the facts of his artistic career are well-charted, knowledge of his private life depends entirely on hearsay. On the one hand, he is depicted as a ladies' man, built like a peasant, strong as an ox, sleeping with countless women, including all of his models. On the other hand, he is seen as a hypochondriac and a confirmed bachelor with a balanced lifestyle, living with his mother and sisters while keeping a studio in the suburbs to which he went to work regularly every day:

"Klimt's daily routines were very bourgeois. He was so engrossed in them that any divergence from his normal course was a horror to him; going anywhere was a major event, and a big trip was only conceivable if his friends did all the shopping for him beforehand, down to the smallest detail." (Hans Tietze, *Gustav Klimts Persönlichkeit nach Mitteilungen seiner Freunde*, 1919)

Klimt never married, but had a long relationship with Emilie Flöge, the sister of his brother Ernst's wife. In 1891, Ernst had married Helene Flöge, one of two sisters who ran a fashion house in Vienna. The marriage only lasted fifteen months, but through Helene Gustav met Emilie. From around 1897 onwards, he spent almost every summer on the Attersee with the Flöge family, periods of peace and tranquility, which produced the landscape paintings constituting almost a quarter of his entire œuvre.

The exact nature of Klimt's relationship with Emilie Flöge remains unknown. They never lived together, and although it was Emilie whom Klimt requested on his death bed, there has always been a great deal of speculation as to whether they were actually lovers.

Klimt corresponded extensively both with Emilie and with Marie (Mizzi) Zimmerman, who was the mother of two of his three illegitimate children. He writes to Marie with great affection and in detail about his work and daily life, whilst to Emilie he appears to write merely in order to communicate information concerning travel arrangements and other such neutral details.

But who is to tell where the truth ultimately lies? It is perfectly possible that more personal correspondence between Klimt and Emilie did exist, but was subsequently destroyed.

His 1902 portrait of Emilie shows an attractive young woman wearing one of her own dresses, many of which Klimt designed for her fashion house, as well as jewelry and textiles. It's a remarkably subdued painting, with just a subtle, tantalising hint of sensuality in the light patch of skin just above the bodice, suggesting the hidden breast beneath. How different from the 1903 painting *Hope I*, which depicts a naked and heavily pregnant woman, Herma, one of Klimt's favourite models.

The story goes that one day Herma, whom Klimt apparently described as having a backside more beautiful and more intelligent than the faces of many other models, failed to turn up for work. Klimt, who took very good care of his models, began to worry and finally sent someone to find out if she was ill. Upon hearing that she was not ill but pregnant, Klimt insisted that she came to work anyway. She then became the model for *Hope I* (p.101).

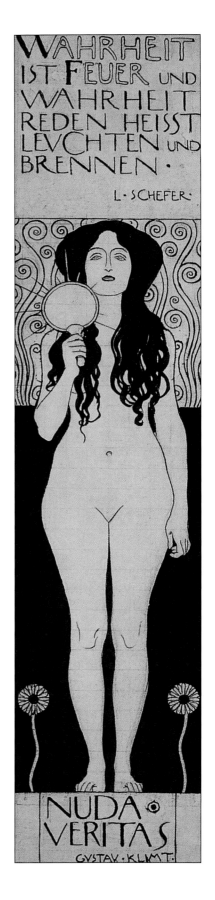

19. Final drawing for *Nuda Veritas*, 1898, black chalk, pencil, indian ink, 41 x 10 cm.

20. *Jurisprudence*, 1907, oil on canvas, 430 x 300 cm, burned in Schloß Immendorf, Austria, 1945.

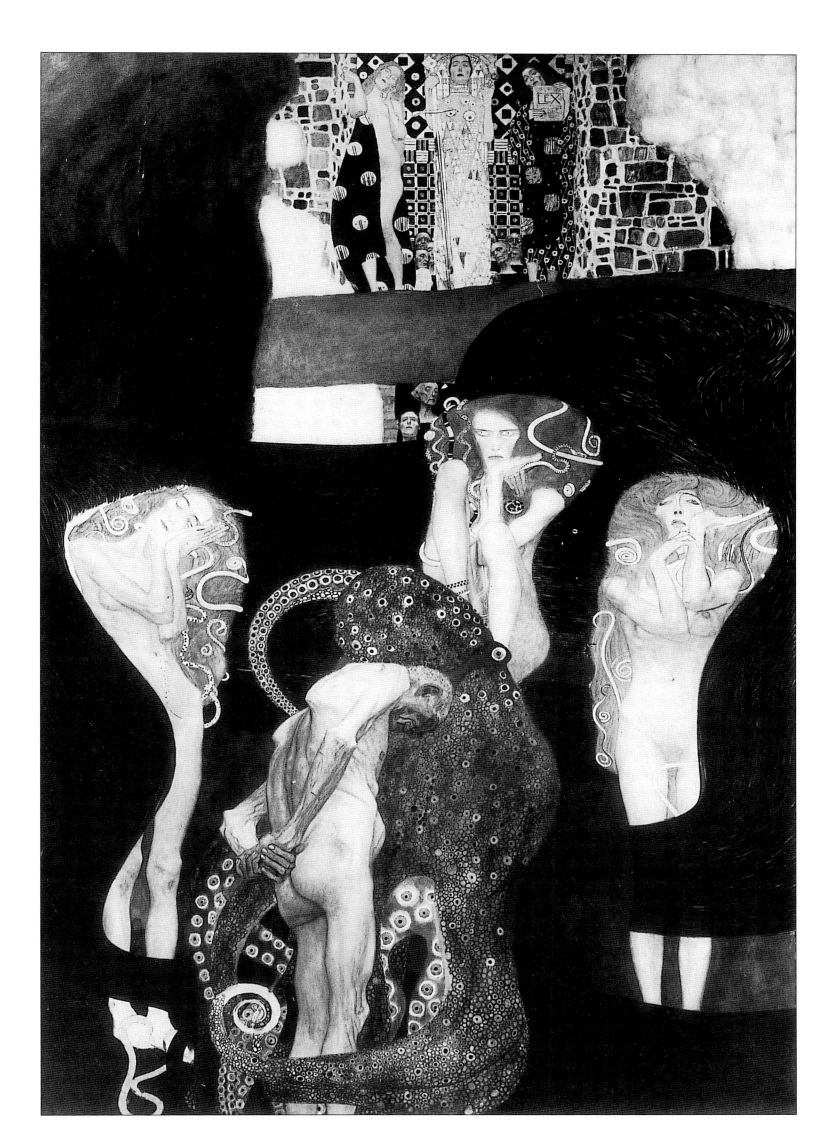

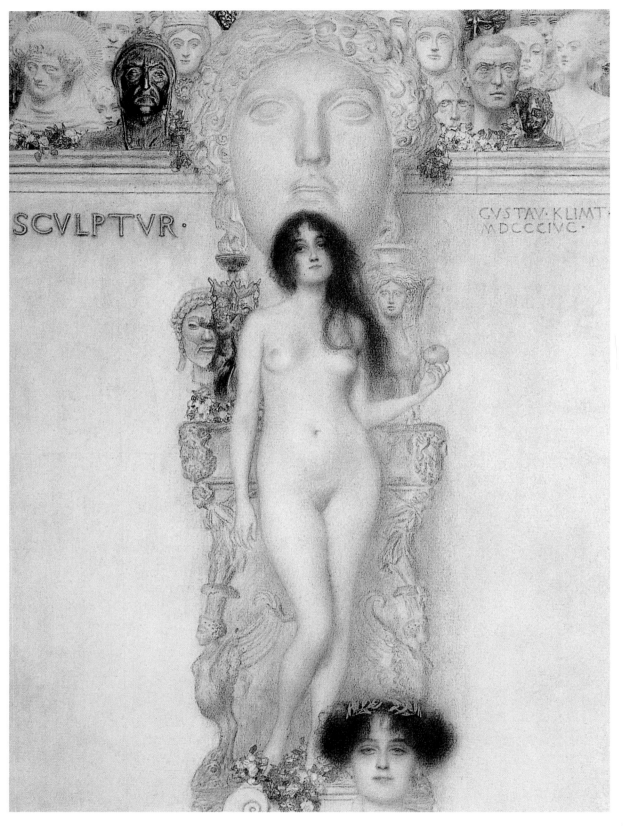

Within the drawing:

SCVLPTVR·

GVSTAV·KLIMT·
MDCCCIVC·

21. *Final Drawing for Allegory
 of The Sculpture*, 1896,
 black crayon, graphite washes
 with gold, 41.8 x 32.3 cm,
 Historisches Museum, Vienna.

22. *Portrait of Josef Lewinsky*, 1895
 oil on canvas, 60 x 44 cm,
 Österreichische Galerie,
 Vienna.

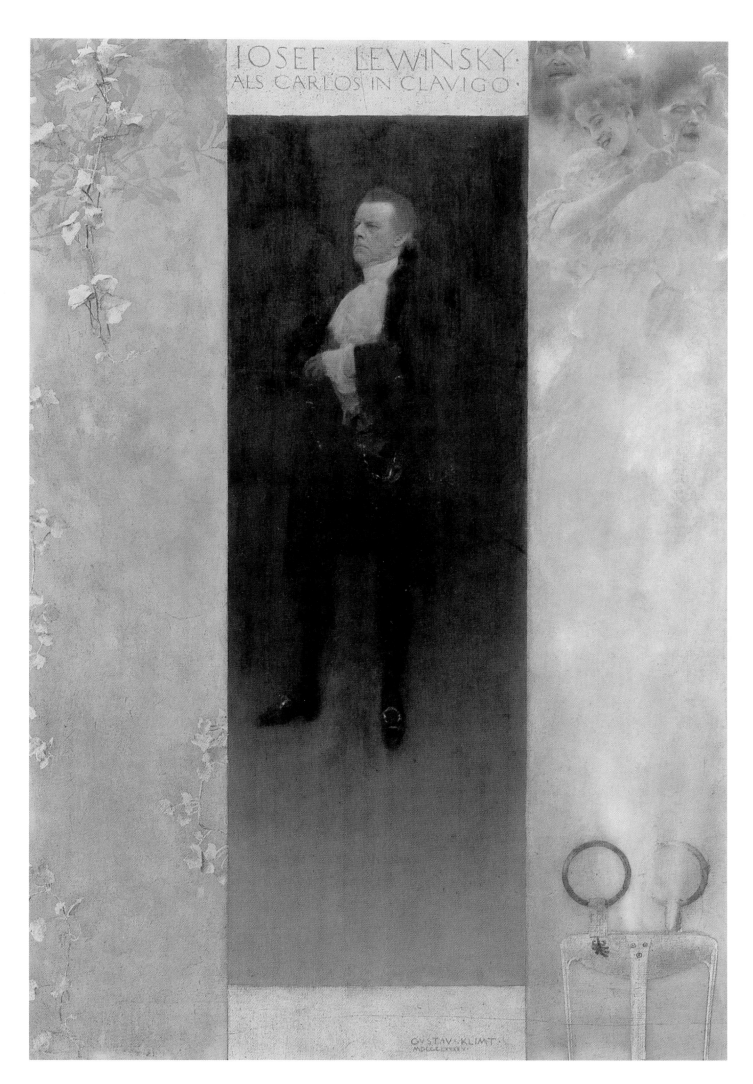

23. *Flowing Water*, 1898
oil on canvas, 52 x 65 cm,
private collection.

This fragile, slender woman looking calmly out at the viewer is anything but maternal. Her figure, apart from her distended stomach, is still that of a young woman, thin to the point of skinniness. Her hair is crowned with flowers as if she were a bride. Depending on one's point of view, her direct gaze and unashamed nakedness shown in profile for maximum effect, are either pointing out the obvious consequences of sex, or inviting a still-sexual response to her body.

The later *Hope II* (p.117), painted in 1907-1908, has a far more maternal feel. The woman's breasts are full and large-nippled, her head bowed in a peaceful, almost Madonna-like pose. She is enclosed by a fabric that follows an abruptly straight line down her back as if she were actually sitting on a straight-backed chair being carried by the figures underneath her. The last great hope of humankind, transported on the backs of other women.

When Klimt died, there were no fewer than fourteen claims that he was the father of an illegitimate child, only three of which were legally upheld – two by Marie Zimmerman and one by Maria Ucicky. (The child was named Gustav after his father and later went on to become a film director). It is generally assumed that he slept with most of his models.

24. *Dead's Procession*, 1903
burned in Schloß Immendorf,
Austria, 1945.

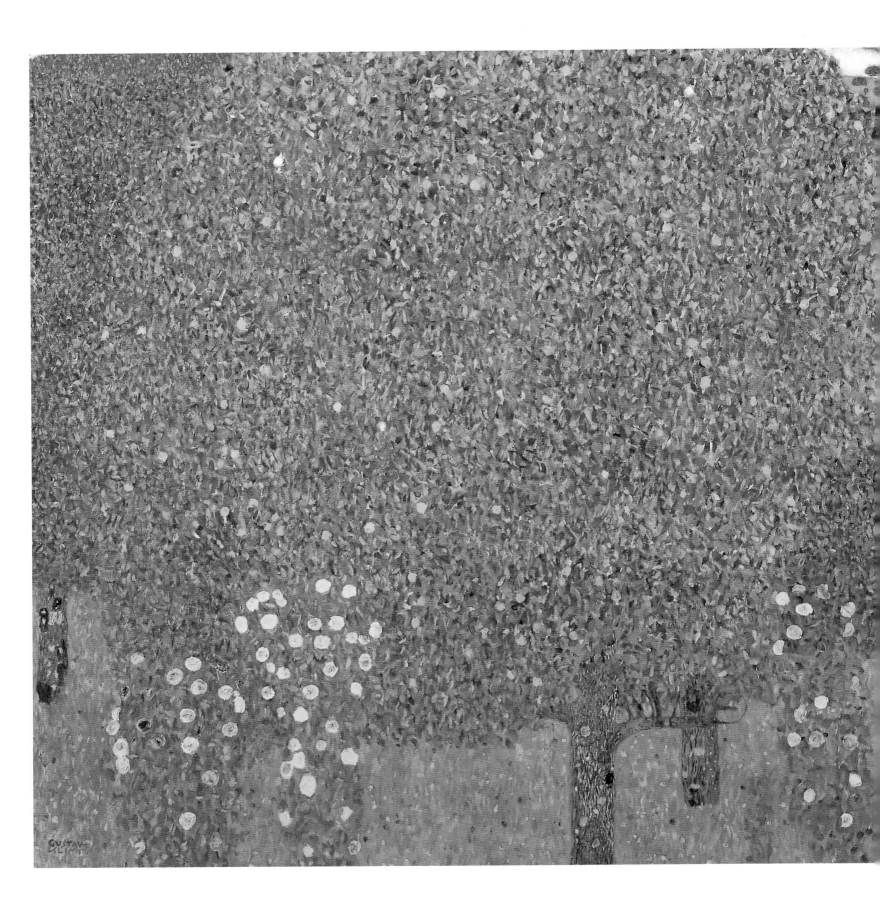

25. *Roses in Trees*, 1905
oil on canvas, 110 x 110 cm,
Musée d'Orsay, Paris.

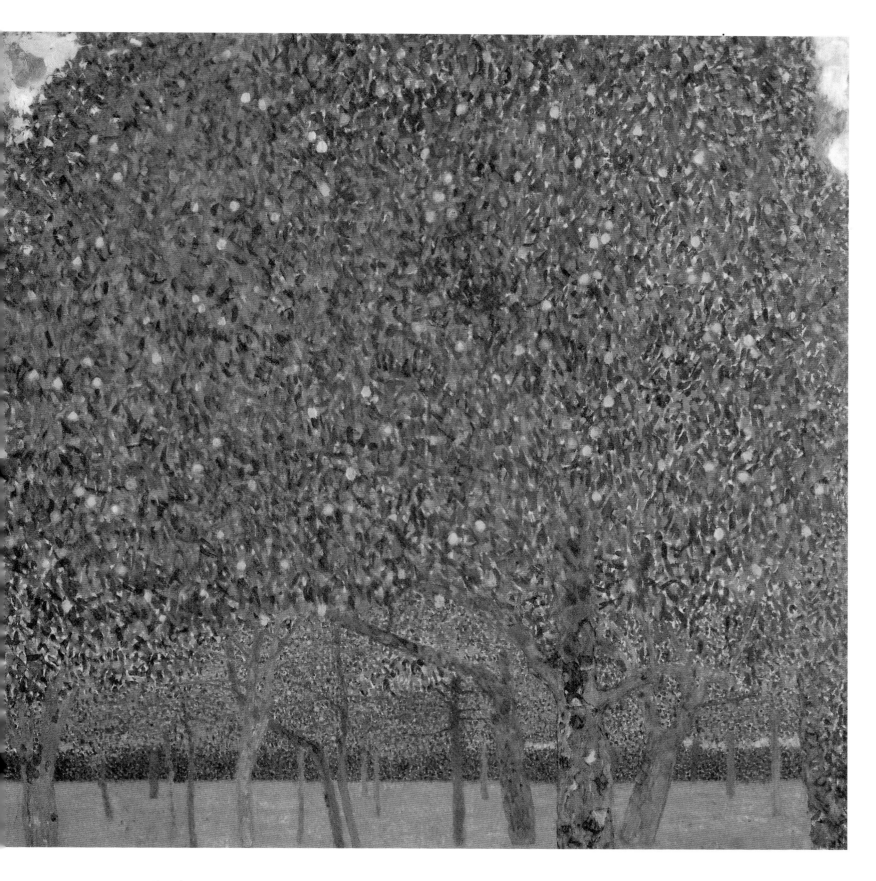

26. *Pear Tree,* 1903, oil and casein
on canvas, 101 x 101 cm,
Harvard University Art
Museums, Cambridge.

He was certainly known to be very generous towards them. Who knows whether the pregnancies depicted in his paintings had any connection with the painter himself? If they did, Herma's gaze in *Hope I* takes on an entirely new meaning: a look of reproach? Or one of irony?

Drawings and sketches

In his studio, Klimt kept girls available to him at all times, waiting for him in a room next door in case he decided to paint them. Franz Servaes, a contemporary art critic, observed: "Here he was surrounded by mysterious, naked female creatures, who, while he stood silent in front of his easel, strolled around his studio, stretching themselves, lazing around and enjoying the day – always ready for the command of the master obediently to stand still whenever he caught sight of a pose or a movement that appealed to his sense of beauty and that he would then capture in a rapid drawing."

Klimt made sketches for virtually everything he did. Sometimes there were over a hundred drawings for one painting, each showing a different detail – a piece of clothing or jewelry, or a simple gesture. They would lie about his studio in heaps, where his adored cats, it is said, had a habit of destroying them.

Unfortunately, however, the bulk of his sketchbooks were destroyed not by cats but by a fire in Emilie Flöge's apartment. Only three of the books survived. The drawings which have survived, however, provide a fascinating insight into Klimt's artistic and personal preoccupations: whereas in his paintings nudity and sexuality are covered, almost imprisoned by ornament and textile to be partially and tantalisingly revealed, in his drawings eroticism is open and undisguised.

Even during his lifetime, his drawings were by some critics regarded as the best work of his entire life's work, but they would not have been widely seen. Luckily then for him that unlike Schiele, who earned his living from his drawings, Klimt's income was derived entirely from his painting. Drawing for him was either a necessary preparatory process or a form of relaxation, a way of expressing himself spontaneously free from the constraints and detail of oil.

Klimt's drawings not only reveal his mastery of illustrating, they also show an erotic obsession and a sexual freedom quite at odds with the covered-up, repressed society in which he moved. In these drawings there is no visual, temporal, or spatial context, just the women themselves, who were presumably, as earlier described, wandering around his studio in a state of undress. He draws them only in outline, omitting any internal modeling or shading of their bodies and almost always drawing attention to their genitalia or breasts by using perspective, foreshortening, distortion or other formal techniques.

A wonderful example of how a couple of pencil strokes can be used to devastatingly erotic effect is the 1905-6 drawing *Friends Embracing*, in which a tiny circle of darkness draws the viewer's gaze automatically between the woman's legs and her buttocks.

The women are frequently depicted masturbating, absorbed in their own sensual pleasures, eyes closed, face slightly averted. How very at ease these women must have felt with Klimt to allow him to portray them in this way!

27. *Young Girl with a Blue Veil*,
1902-1903
oil on canvas, 67 x 55 cm,
private collection.

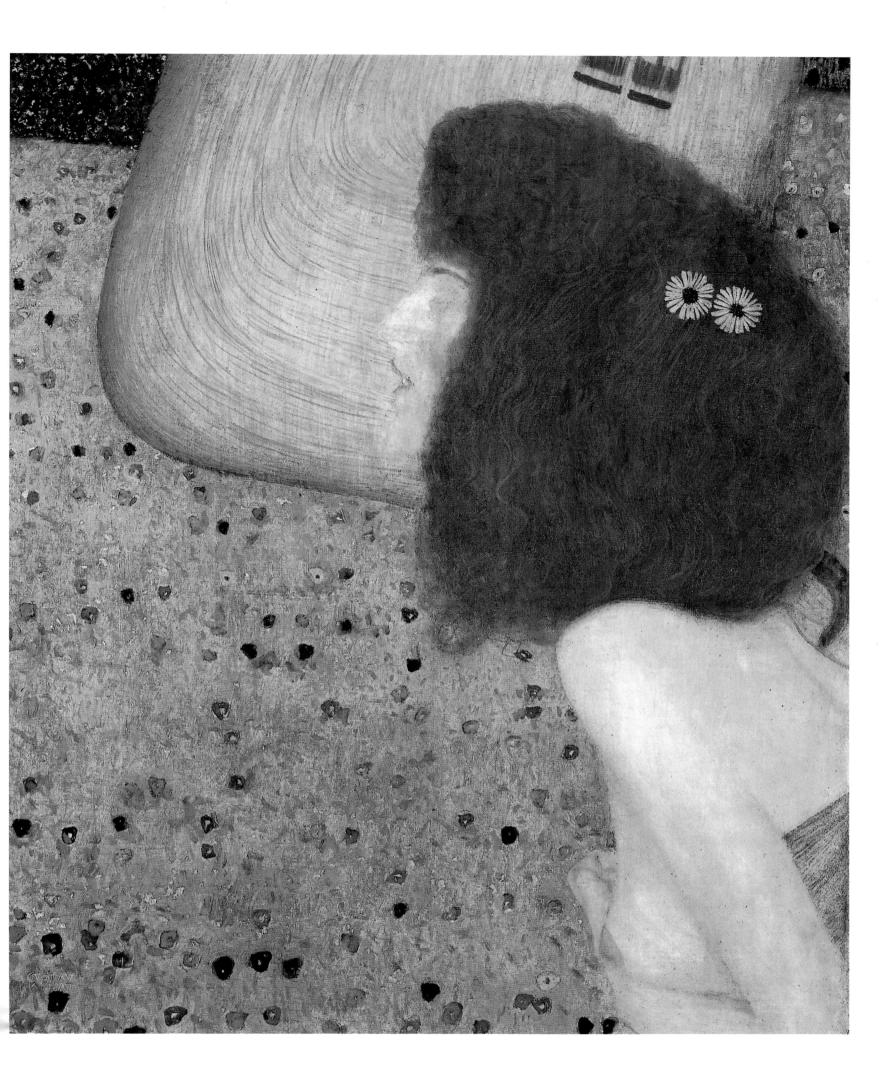

35.

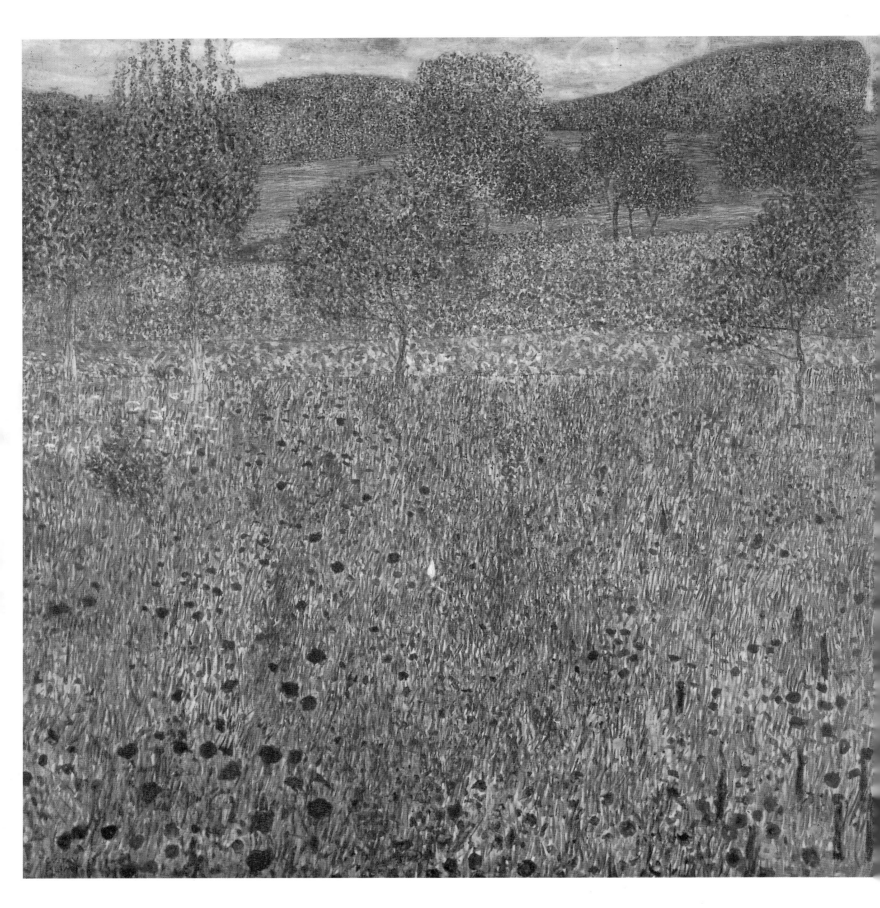

28. *Orchard*, 1905-1906
oil on canvas, 98.7 x 99.4 cm,
The Carnegie Museum of Art,
Pittsburgh.

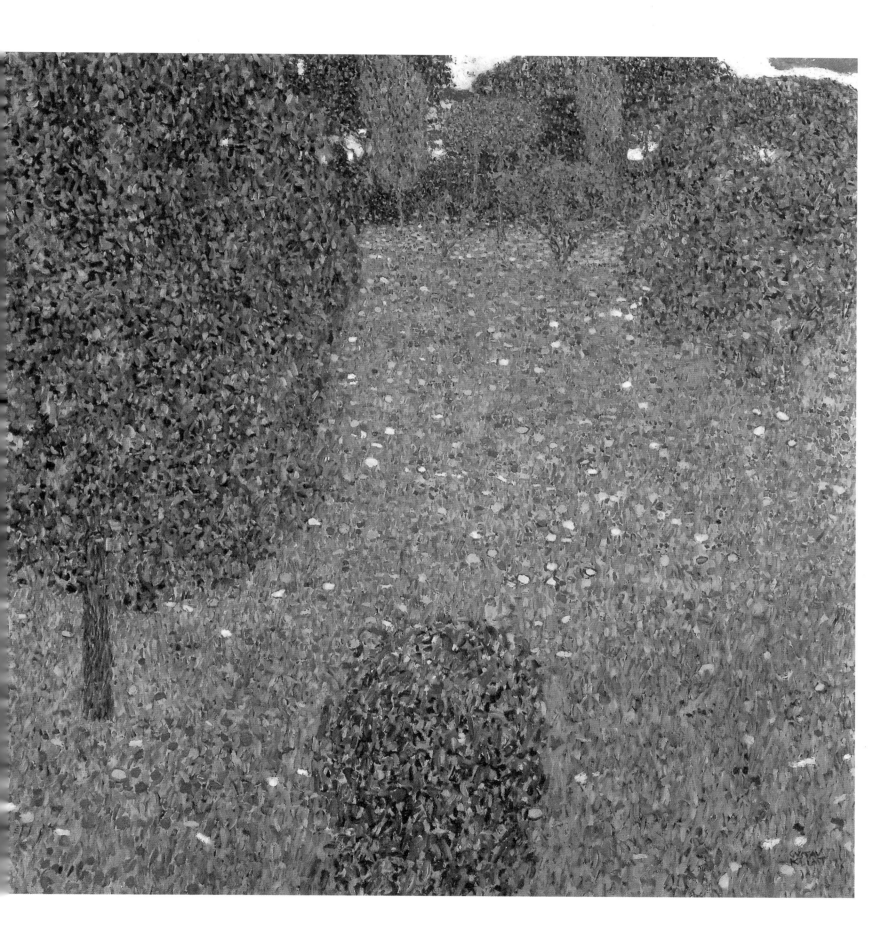

29. *Garden Landscape*, 1906
oil on canvas, 110 x 110 cm,
private collection.

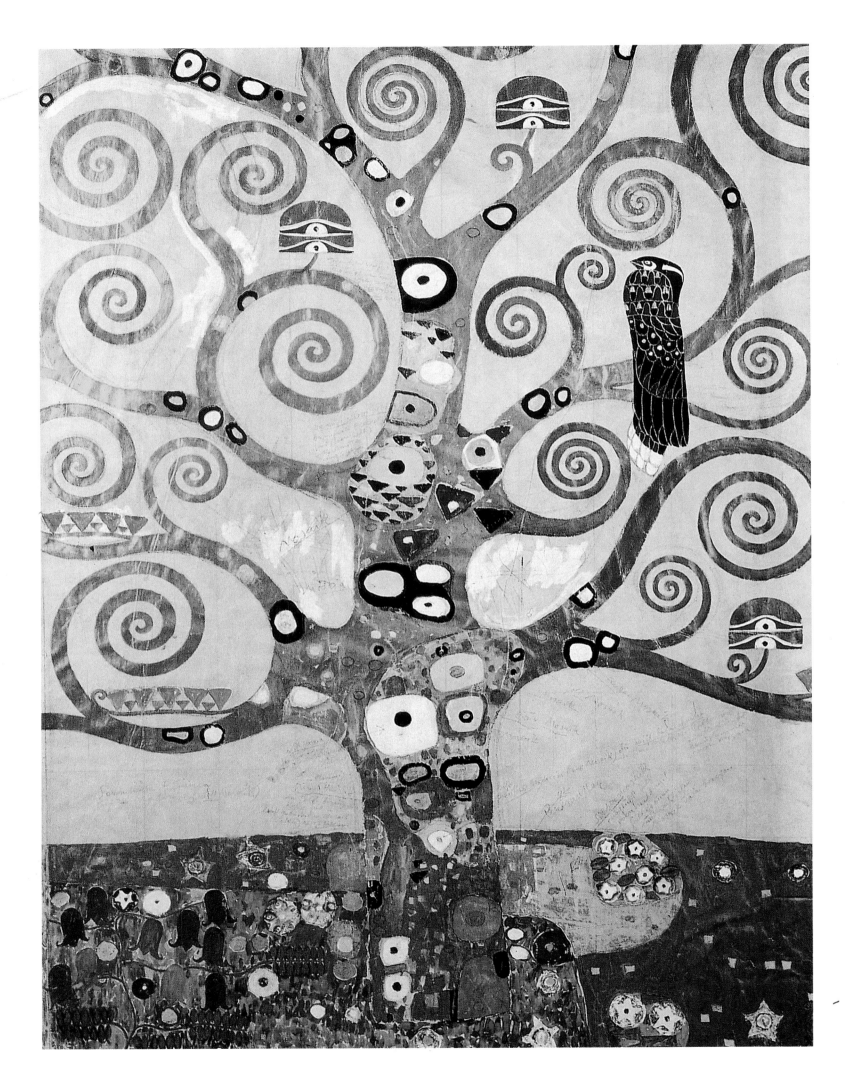

Languorous, feline, and utterly absorbed, they masturbate delicately, fingers poised above the clitoris, still fully or partially clothed, eyes closed in the imaginary heat of a summer's afternoon.

Sometimes Klimt draws in great detail, sometimes it is the overall pose that clearly interests him. Men rarely make an appearance in these drawings, and when they do they are almost uniquely depicted with their back to the viewer. In general, apart from academic studies at art school, men are peripheral figures in Klimt's paintings. Their faces are rarely shown, and they seem to exist either as voyeurs or simply as the physical partner to a sexual act, of which the woman is the main point of interest for the viewer. What is extraordinary in Klimt's work is that, while expressing his clear admiration for women's beauty, when he shows men and women together he articulates a kind of remoteness, a gulf between the sexes.

In his painting *The Kiss* (p.119), the man's face cannot be seen. He holds the woman up, his hands clasped round her face in a gesture of great tenderness, yet her face is turned away from his embrace: he is offered only her cheek to kiss, and her hand looks almost as if she were trying to pull his away. Auguste Rodin's earlier sculpture *The Kiss*, by contrast, shows both lovers fully engaged in their embrace. It is a tender, romantic and sensual moment equally involving both partners. One could assuredly interpret this lack of direct contact in Klimt's painting in other terms – her face is turned towards us so that we can admire its peaceful beauty, for example – but another sketch of 1903-1904 presents a series of images that underline the first interpretation: the figures are seated in a pose similar to that of the lovers in Rodin's sculpture. The man, however, seems unable to make any physical contact with the woman, desperately though he tries. He clasps her to him, leans over her, and finally leans on top of her in an attitude of despair. Are we to infer from this a vision of the world in which men desperately seek love from women who, though appearing open to this contact, actually possess a quiet, independent world quite inaccessible to men?

One of Klimt's amorous liaisons might suggest so. Alma Mahler-Werfel (then Schindler) knew Klimt when she was a young girl of seventeen and claims that he was in love with her. She was not a modest diarist by any means, but there is no reason to doubt the truth of the affair, especially in the light of a later letter of apology written by Klimt to her stepfather, Carl Moll. Alma later made something of a career out of having relationships with artists: she was married three times, first to Gustav Mahler, then to the architect Walter Gropius, then finally to the Prague poet Franz Werfel, with a wild love affair with Oskar Kokoschka thrown in for good measure in between.

Of her youthful infatuation with Klimt she writes: "He was the most gifted of them all, thirty-five years of age, at the zenith of his powers, beautiful in every sense of the word and already famous. His beauty and my youthful freshness, his genius, my talents, the profound life-melody we shared touched the same chords in us both. I was ridiculously ignorant of all things passionate – and he felt and found me everywhere ... He was bound by a hundred chains: women, children, even sisters who fought over him. But he still followed me..."

30. *Tree of Life*, c. 1905-1909
195 x 102 cm,
Museum für Angewandte
Kunst, Vienna.

31. *Waiting*, c. 1905-1909
Mural work for the Stoclet
Frieze, 193.5 x 115 cm,
Österreichisches Museum,
Vienna.

32. *Accomplishment*, c. 1905-1909
Mural work for the Stoclet
Frieze, 194.6 x 120.3 cm,
Österreichisches Museum,
Vienna.

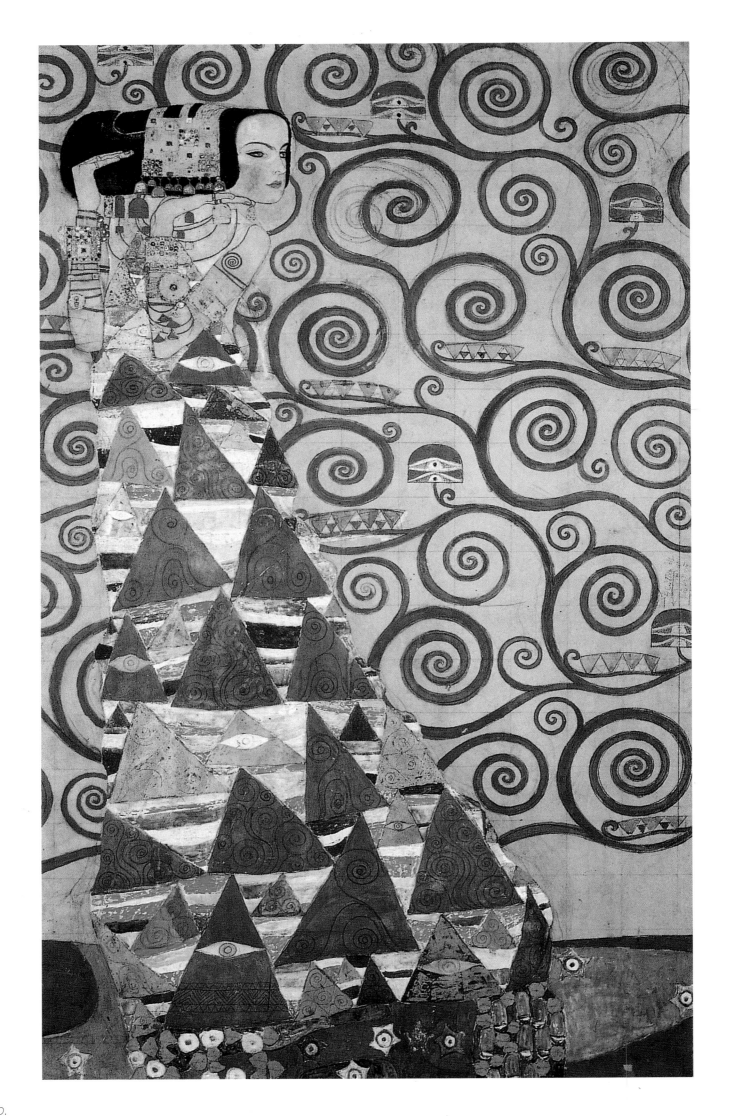

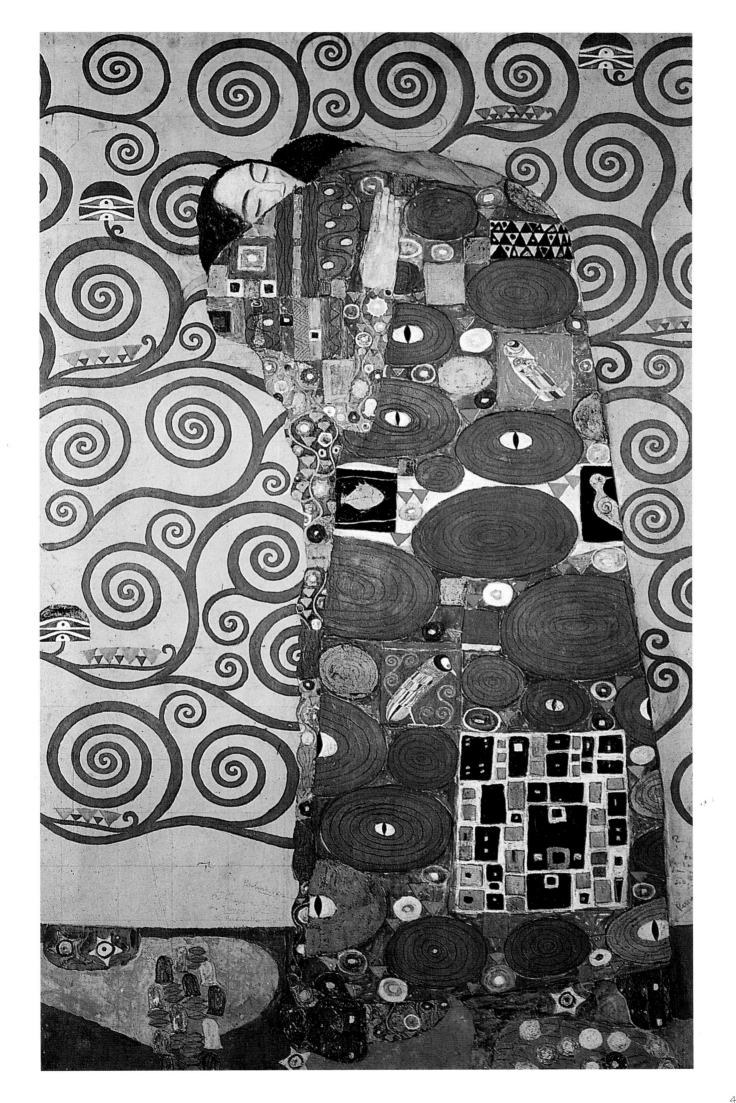

Society portraits

The freedom of Klimt's drawings stands in marked contrast with the portraits of society women he produced between 1903 and around 1913 where the women in his drawings are unconstrained either by clothes or by social conventions. He depicts Fritza Riedler and Adele Bloch-Bauer awash in a sea of pattern and ornament. Their faces stand out, serious and composed, before blocks of pattern or colour strategically placed behind their heads to emphasize their features to the maximum. Their bodies are submerged in swathes of textile patterns merging with the background so that the face appears isolated, fragile, alone.

The Portrait of Margaret Stonborough-Wittgenstein (p.109) is notable as one of the few which is not dominated by pattern, and is a clear tribute to the work of Whistler, whom Klimt greatly admired. There is also something particularly striking in the gaze and stance of the young Maria Primavesi: she stands, hand on hip, legs apart, the age-old combination of innocence and provocation. These are remarkably delicate portraits.

33. *Girlfriends*, 1905
 black chalk, 45 x 31 cm,
 Historisches Museum, Vienna.

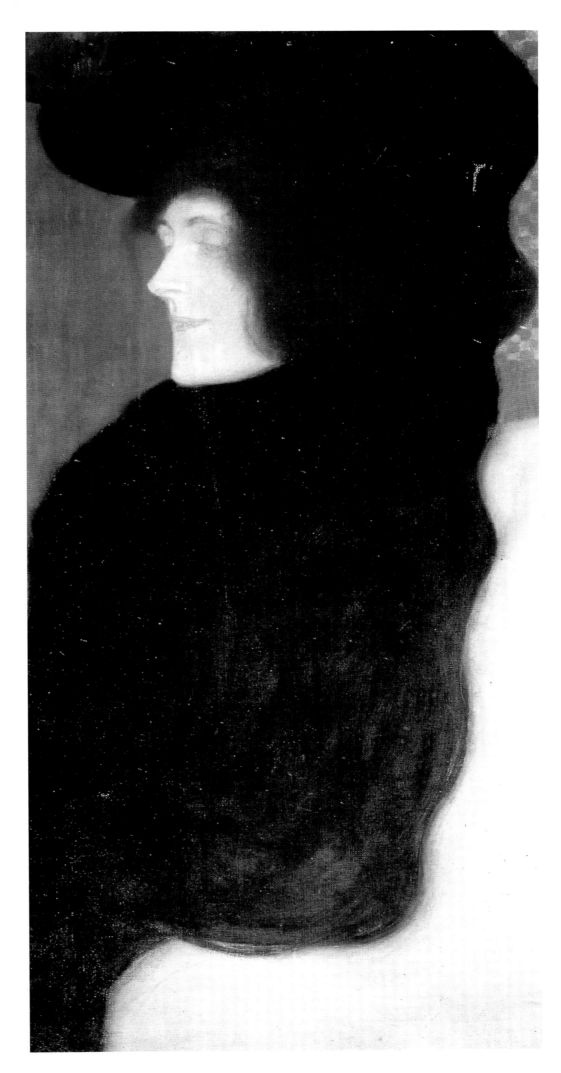

34. *Pallid Figure*, 1907
 oil on canvas, 80 x 40 cm,
 private collection.

35. *Pond at Kammer Castle
on the Attersee*, 1909
oil on canvas, 110 x 110 cm,
private collection.

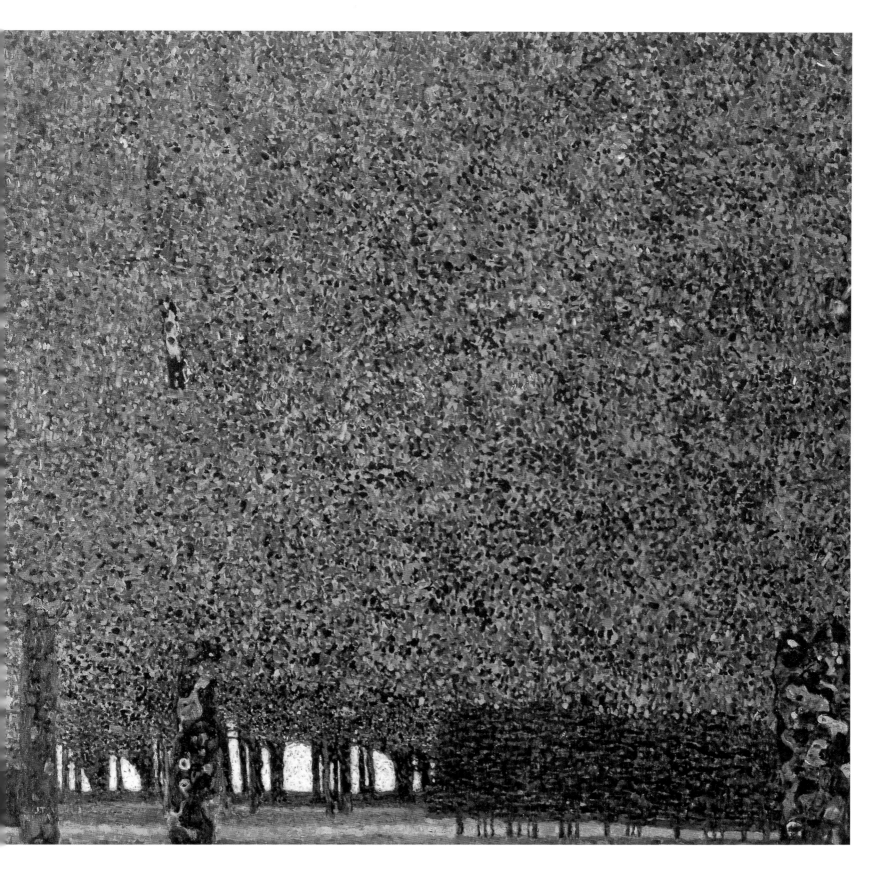

36. *The Park*, 1909-1910
 oil on canvas, 110.5 x 110.5 cm,
 Museum of Modern Art,
 New York.

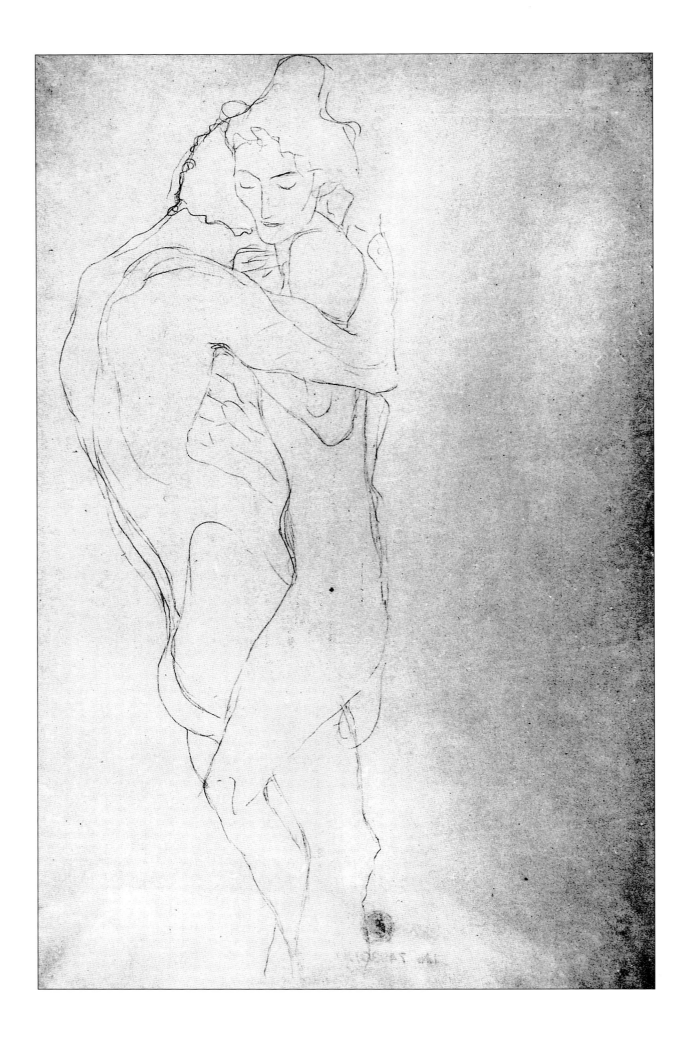

46.

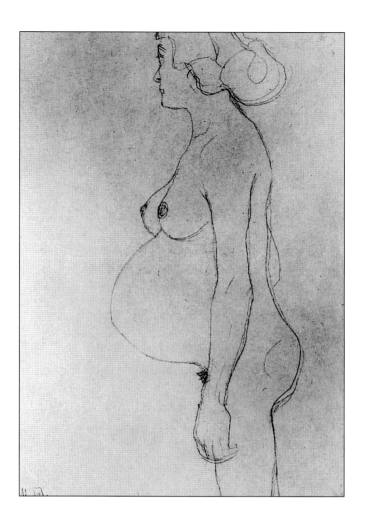

Each face betrays so much about the sitter – a calmness, or an awkwardness, and in Adele Bloch-Bauer's, the only one of these women known also to have been Klimt's lover, it is difficult not to read into her face a desire to pose as luxuriously as Klimt's models did, especially in the 1912 portrait, where her open lips, her gaze, and her direct stance suggest a certain sexual readiness in stark contrast to the upright behaviour which would undoubtedly have been expected of her.

Pattern and nudity

In Klimt's paintings from the last ten years of his life, pattern, textile and ornament are used to highly erotic effect, emphasizing the nakedness of the body rather than covering it up. It is as if the women he depicts are imprisoned by the textiles and ornaments, an impression heightened by the artist's heavy use of gold (Klimt had visited Ravenna in 1903, where he had greatly admired the famous Byzantine mosaics).

In *Judith II* (p.129) the clothes seem barely able to contain the energetic nudity of the avenging woman, and in *Bride* (p.153) textiles are used as a way of isolating shapes and body parts to create a highly erotic effect.

Heads and torsos become fragmented, detached from their bodies. The figure on the far left of the painting almost resembles Man Ray's photograph of a woman's back as a cello, and the figure to the far right of the canvas has her head totally obscured, leaving her breasts exposed while the lower part of her body is covered by a sexy, see-through skirt leaving her legs open and genitals clearly visible.

37. *Lying Lovers*, 1908
 black chalk, 35 x 55 cm,
 Historisches Museum, Vienna.

38. *Pregnant Nude, Standing, Left
 Profile* study for *Hope II*, 1907
 black chalk, 49 x 31 cm,
 Historisches Museum, Vienna.

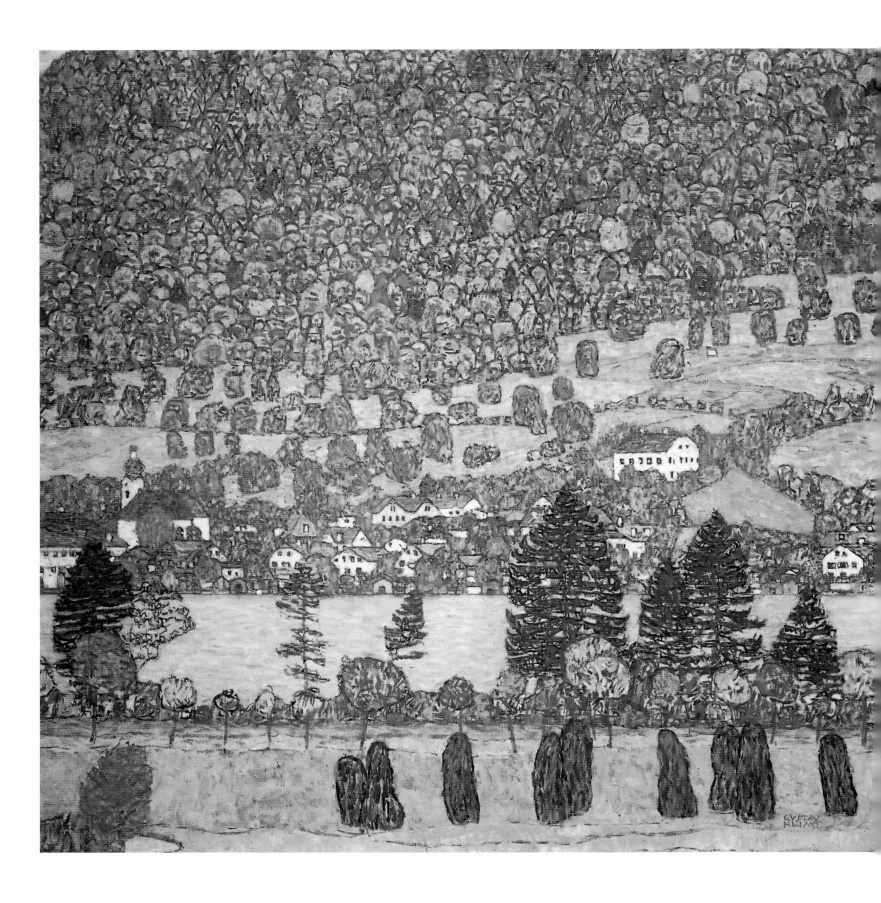

39. *Forest in a Slope Mountain at Unterach on The Attersee,* 1917
oil on canvas, 110 x 110 cm
private collection.

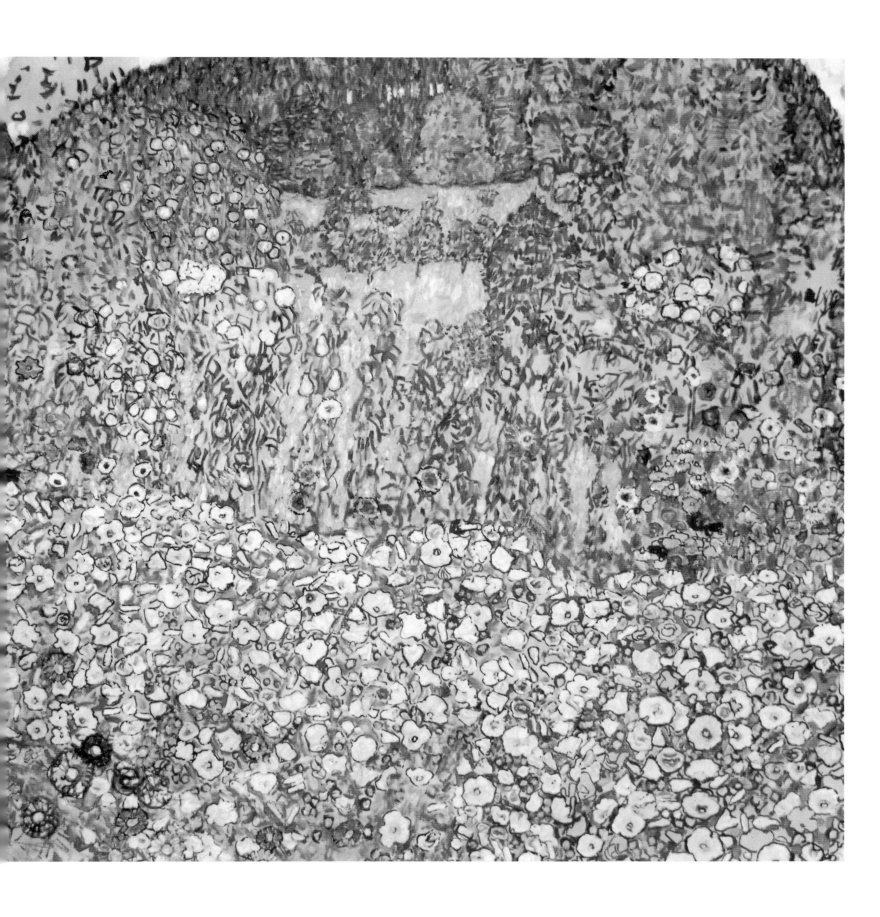

40. *Garden and Summit of a Hill,* 1916
oil on canvas, 110 x 110 cm
Kunsthaus Zug, Switzerland.

The fact that the provocatively naked body exists beneath these skimpy clothes might even suggest, as some of Klimt's preparatory drawings imply, that in other paintings he actually drew the naked body first, then covered it with textiles and pattern. This, at least, is the impression one has when looking at paintings such as *Virgin* (p.137) in which the young girl, depicted asleep, is lying flat on her back in a pose at once innocent and sexually exposed. The clothes look as if they have been thrown on top of her as if to hide her sexual dreams, represented by the mass of semi-naked, presumably more knowing women underneath her.

Klimt's Legacy

During his entire lifetime, Klimt made only one statement about himself and his art: "I am certain that there is nothing exceptional about me as a person. I am simply a painter who paints every day from morning till night. ... I'm not much good at speaking and writing, especially when I have to discuss myself or my work. Just the idea of having to write a simple letter fills me with anguish. I am very much afraid that you will have to do without a portrait of me, either painted or in words, but that is no great loss. Whoever seeks to know me better, that is to say as an artist – and that's the only thing worth knowing – should study my paintings and try to glean from them who I am and what I want."

Just how exceptional Gustav Klimt was is perhaps reflected in the fact that he had no predecessors and no real followers. He admired Rodin and Whistler without slavishly copying them, and was admired in turn by the younger Viennese painters Egon Schiele and Oskar Kokoschka, both of whom were greatly influenced by Klimt. But whereas Klimt belongs to that transitional period at end of the nineteenth century, Schiele and Kokoschka represent the beginnings of that quintessentially early twentieth-century movement, expressionism.

Schiele, like Klimt, produced many drawings of nudes, but where Klimt's drawings were peaceful, dreamy and delicate, Schiele reflected a tortured and neurotic psyche. He drew himself endlessly – an emaciated, troubled figure – and his drawings of female nudes manage to render the women simultaneously sexually attractive and repulsive.

On January 11, 1918, Klimt suffered a stroke that left him partially paralyzed on one side. Although he seemed to be recovering, he died a month later. After his death opinion was still divided as to his merits as an artist.

Hans Tietze, a friend of Klimt and author of the first monograph on the artist, sums up his importance:

"Klimt took Viennese painting ... out of the isolation in which it was languishing and back again into the wide world ... At the turn of the century he, more than anyone else, guaranteed the artistic individuality of Vienna."

Klimt, it has been said, could not have existed anywhere but in Vienna. So totally have the images created by him come to represent the Austrian capital at that time that it could indeed be argued that Vienna could not have entered into the twentieth century without the bold vision and artistic individuality of Klimt.

41. *Garden in Bloom,* 1905
 oil on canvas, 110 x 110 cm,
 private collection.

42. *Portrait of Johanna Staude,* 1917
 oil on canvas, 70 x 50 cm
 Österreichische Galerie,
 Vienna.

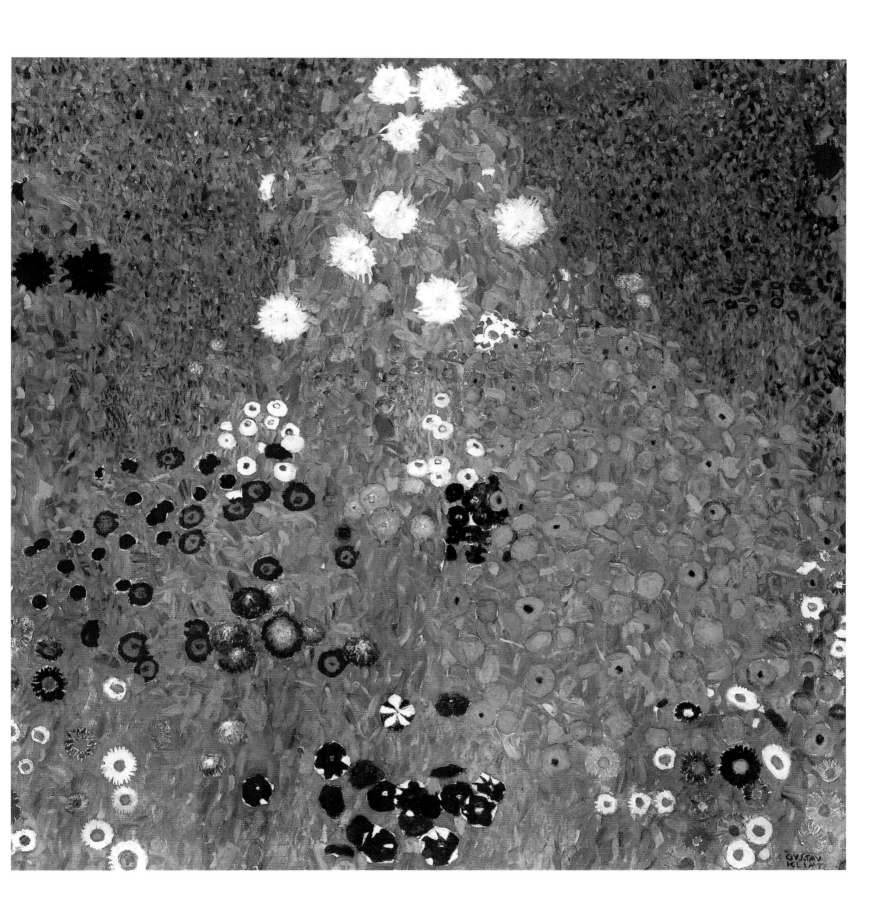

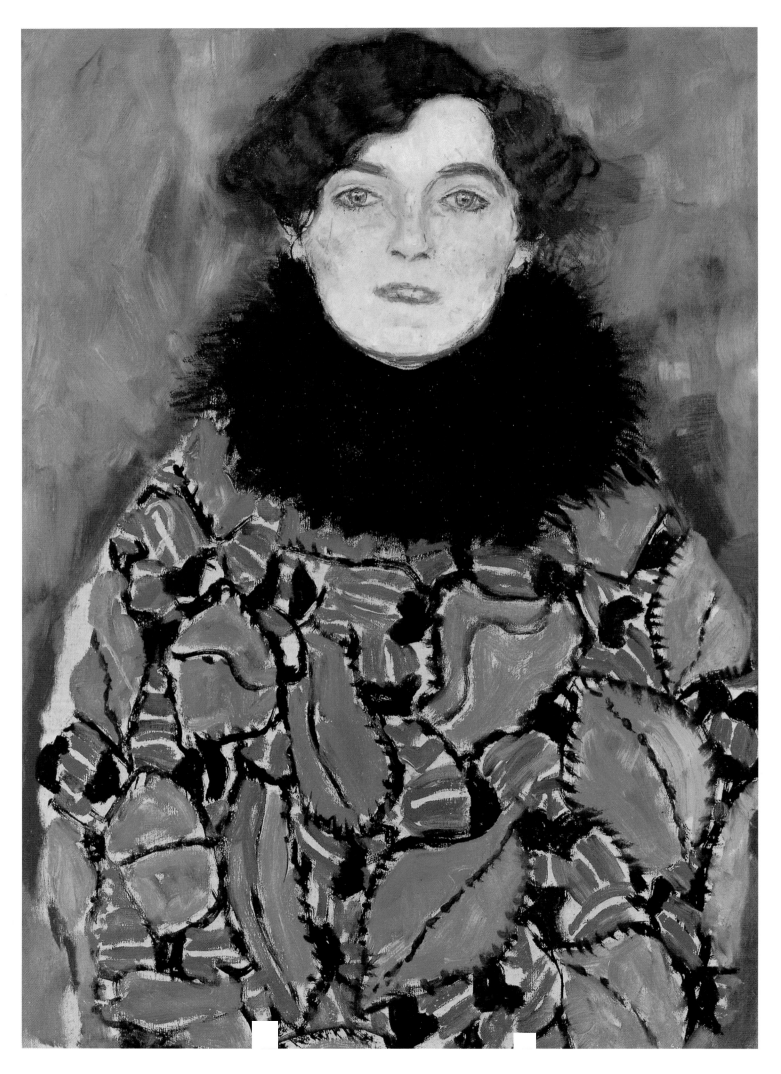

His work

FABLE

1883
Oil on canvas
85 x 117 cm
Historisches Museum Vienna

Fable was painted in 1883, the year that Klimt and his brother Ernst graduated from the *Kunstgewerbeschule* (School of Arts and Sciences) in Vienna. It resulted from a commission to produce designs for a three volume book entitled, *Allegories and Emblems* that was intended to update the traditional allegorical language used by artists in order to encompass aspects of modern life such as commerce and technology. Amongst the other artists who contributed to this prestigious publication were two who were later to be seen as principal rivals to Klimt in the German speaking world – Max Klinger and Franz von Stuck. Though an accomplished piece of work for a twenty one year old, and attractive in its own way, *Fable* shows no hint of the distinctive style for which Klimt was to become famous more than a decade later. At this stage in his career Klimt was completely under the spell of the so-called "Painter Prince", Hans Mackart, then at the height of his fame and to be forever associated with the pompous overblown historicism of the newly constructed public buildings on the Vienna Ringstrasse. As a student, Klimt had been so in awe of Makart that he and his brother Ernst and their fellow student Franz Matsch bribed Makart's servant to let them into the artist's studio to inspect his vast works while the Master took his siesta.

IDYLL

1884
Oil on canvas
49.5 x 73.5 cm
Historisches Museum, Vienna

*I*dyll was also painted to illustrate *Allegories and Emblems.* Right from the beginning Klimt was a magpie borrower from other artists, and *Idyll* shows his careful study of the masters of the Italian Renaissance and the Baroque. The muscular male nudes (a rarity in the work of an artist so completely fixated on the female body) derive ultimately from the "Ignudi" in Michelangelo's Sistine Ceiling but also make nodding reference to the *trompe l'œil* painted male nude sculptures in Annibale Carracci's Farnese Gallery, that seem to project out of the painted surface into real space. For all Klimt's historical references, the physical type of the blonde, female nude in the roundel and the leafy background, reminiscent of a William Morris wallpaper, indicate unmistakably that this is a work of the late nineteenth century. The muted colours of both *Fable* and *Idyll* reflect not only the musty historicism of contemporary taste but also the fact that these designs were meant for printed reproduction.

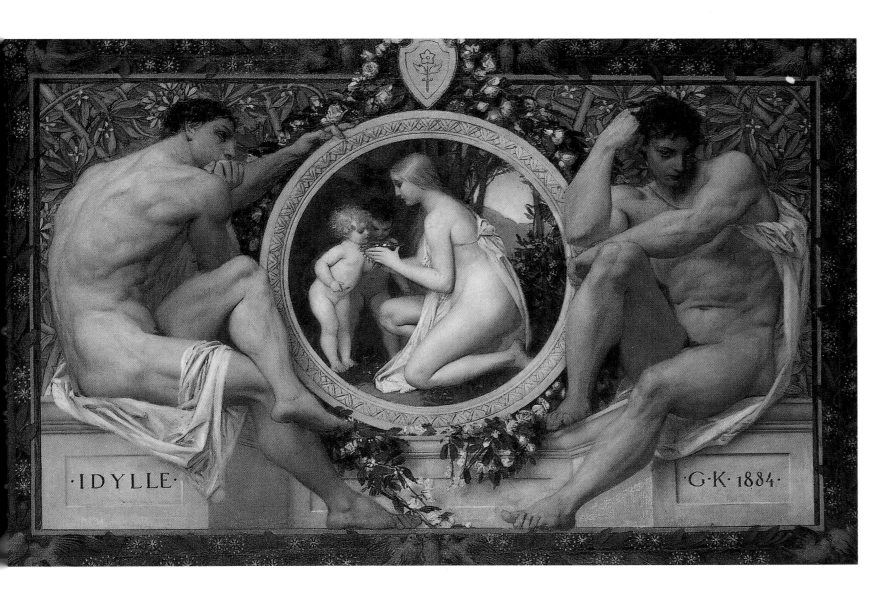

IDYLLE · · G·K· 1884 ·

FEMALE NUDE LYING DOWN

1886-1887
Black pencil with white highlights
28.7 x 42.5 cm
Graphische Sammlung Albertina, Vienna

This drawing shows Klimt's thorough grounding in the skills of academic sketching. The model lies in a stationary reclining pose that could be held for hours if necessary, allowing the artist or student to ensure anatomical accuracy and a high degree of finish. It is very different from the momentary and spontaneous poses that Klimt preferred in later years for his rapid life sketches. Years of training, drawing first from plaster casts and later from live models, ensured that nineteenth artists had highly developed skills, but tended to iron out individuality. This drawing, pleasing and competent though it is, could have been made by almost any academically trained artist, anywhere in Europe. Despite his enormous natural talent, Klimt was surprisingly slow in throwing off his constraining academic background and developing a personal style. It was not until the late 1890s when Klimt was already in his late 30s, that Klimt's distinctive artistic personality began to emerge.

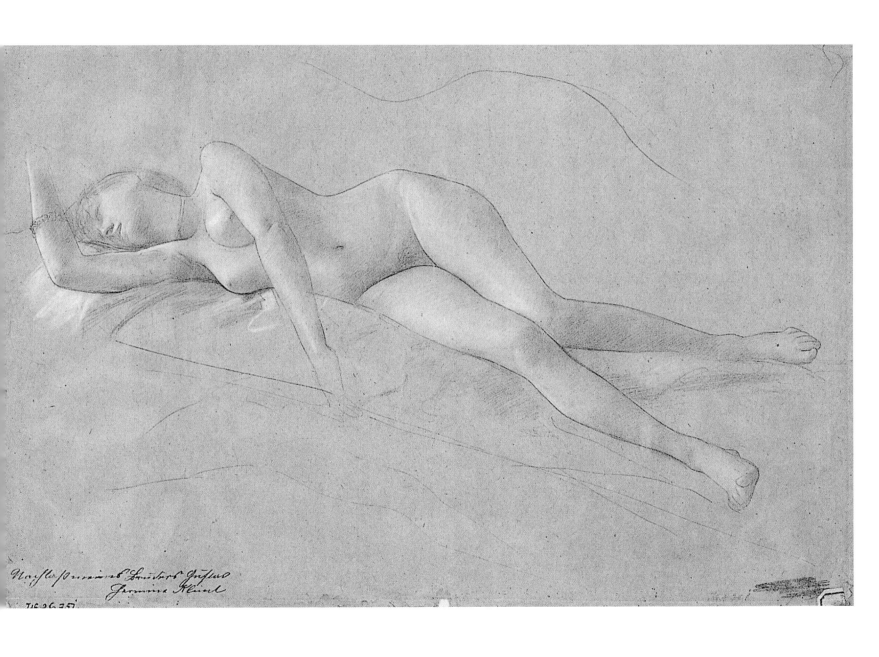

Naßlaßammel Survivob Iufus
Gomme Klind
T.C. 9 C. 7.5?

59.

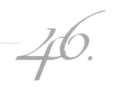

THE THEATRE IN TAORMINA

1886-1888
Oil on canvas
750 x 400 cm
Burgtheater, Vienna

In the 1880s Gustav Klimt, together with his brother Ernst and their friend and former fellow student Franz Matsch, established a reputation for producing large scale decorative schemes for theatres in cities that looked to Vienna for inspiration such as Karlsbad, Bucharest and Fiume. More prestigious still was the commission in 1886 to decorate the ceilings in the two monumental staircases that led to the boxes in the newly constructed Burgtheater on Vienna's Ringstrasse. This magnificent building realised by the veteran theatre architect Gottfried Semper in collaboration with Karl von Hasenauer, was one of a string of buildings that collectively formed an astonishing architectural fancy dress ball around the Ringstrasse in what was, after Haussmann's rebuilding of Paris, the most ambitious scheme of urban renewal in the nineteenth century. With his paintings illustrating the history of theatre from ancient times onwards, Klimt established himself as the legitimate successor to Hans Makart as Vienna's most admired decorator of public spaces. At the same time, though he distanced himself from Makart's old masterful methods by adopting a bright, slick technique closer to that of Parisian academic artists such as Gerome and Bouguereau, and to the brightly coloured and meticulous archaeological reconstructions of the Victorian painter, Sir Lawrence Alma-Tadema. The completion of the Burgtheater scheme was greeted with general praise and marked the highpoint of Klimt's success as a historical painter in conservative art circles. For this work he received the prestigious award of the Gold Cross of Merit.

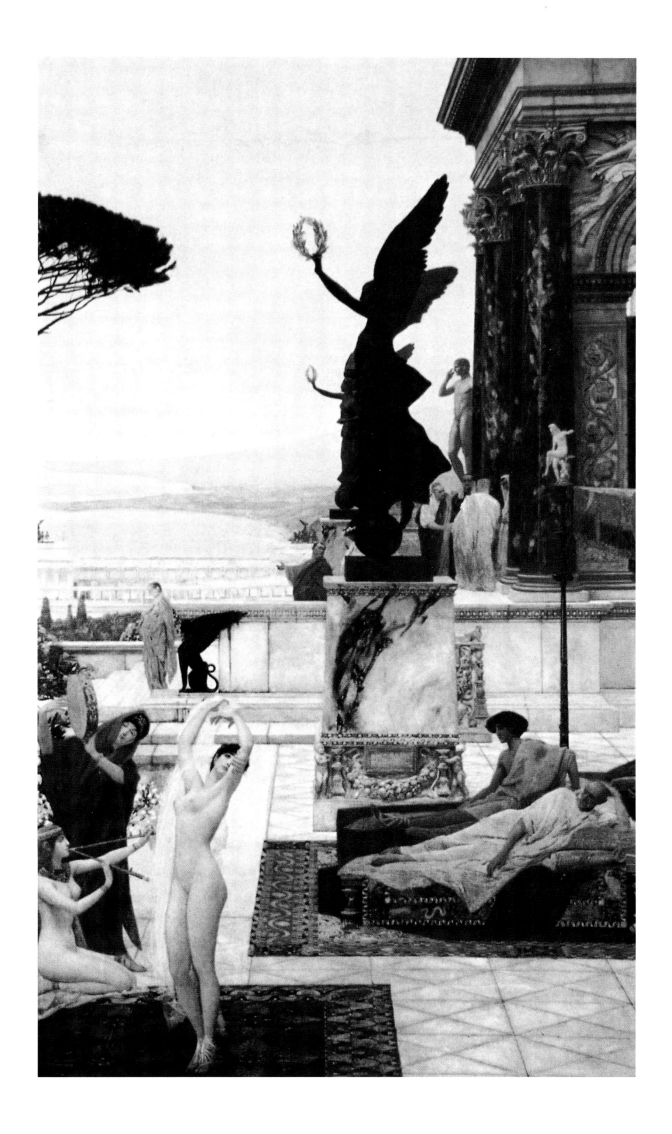

AUDITORIUM IN THE OLD BURGTHEATER, VIENNA

1888
Gouache on paper
82 x 92 cm
Historisches Museum, Vienna

Klimt's 1888 gouache of the *Auditorium in the Old Burgtheater* provides a valuable document, not only of the Viennese theatre-going public of his day but also of the historic theatre in which Mozart's *Marriage of Figaro* had first been performed in 1786. Unfortunately, the theatre was later demolished to make way for the pompous new wing of the Hofburg palace. Despite the quasi-photographic realism of the individual figures the overall effect of this picture is curiously stilted and artificial as if it were an elaborate collage, with the figures not interacting with one another or even inhabiting the same space. Far removed from the exciting and innovative styles that Klimt would develop a decade later, or indeed that Van Gogh and Gauguin were developing in France in that very year, this meticulous and skilful gouache found favour with the arbiters of official taste in Vienna. In 1890 it won the artist the Emperor's Prize of 4,000 guilders.

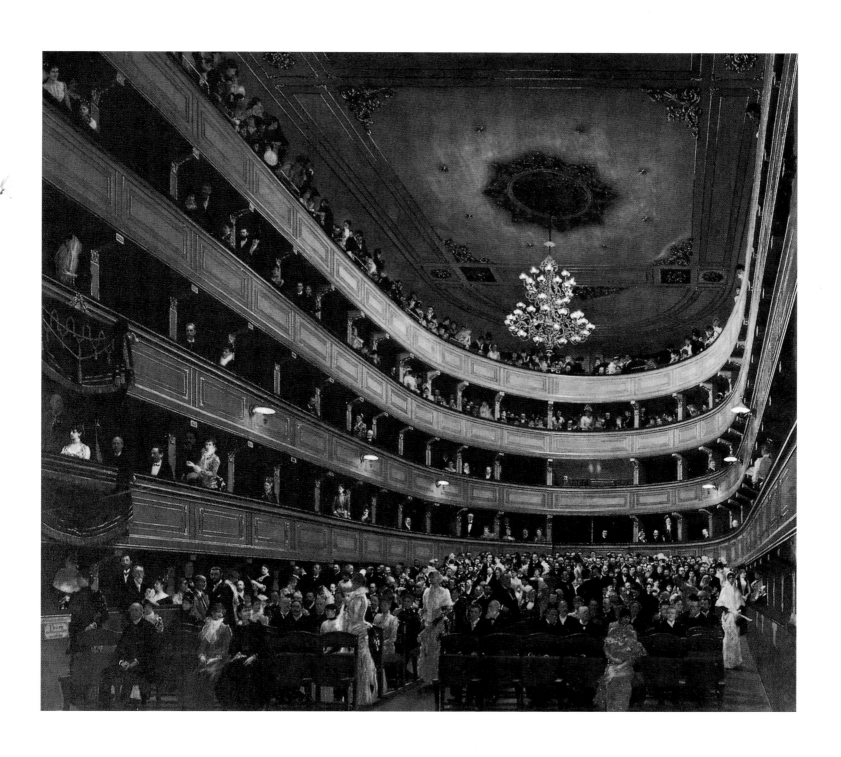

PORTRAIT OF
JOSEPH PEMBAUER

1890
Oil on canvas
69 x 55 cm
Tiroler Landesmuseum Ferdinandeum,
Innsbruck, Austria

Portraits of men are extremely rare in Klimt's works. During his later years Klimt would only accept commissions to paint the portraits of beautiful women. The decidedly unattractive Joseph Pembauer would seem to have been an unlikely subject for Klimt. The convivial pianist, teacher and composer was honoured by the creation of the "Pembauer Society" whose members gathered on a Thursday at the Löwenbräu tavern in Vienna. It was for this Pembauer Society that Klimt painted this small portrait in 1890. Like several of his portraits of around this time, it gives the impression of having been painted from a photograph rather than from life. As in the spandrel decorations for the staircase of the Kunsthistorische Museum which he was painting at the same time, Klimt places the strongly three-dimensional figure against a flatly decorative background. Perhaps the most interesting feature of the picture is its decorative frame. We see the results of the study Klimt made of ancient Greek vases while researching for his murals for the Kunsthistorischesmseum, in his use of the Delphic tripod that Klimt lifted from a fifth century BC Attic red figure vase. He would re-use this motif later in his design for a cover of *Ver Sacrum*, the magazine of the Vienna Secession.

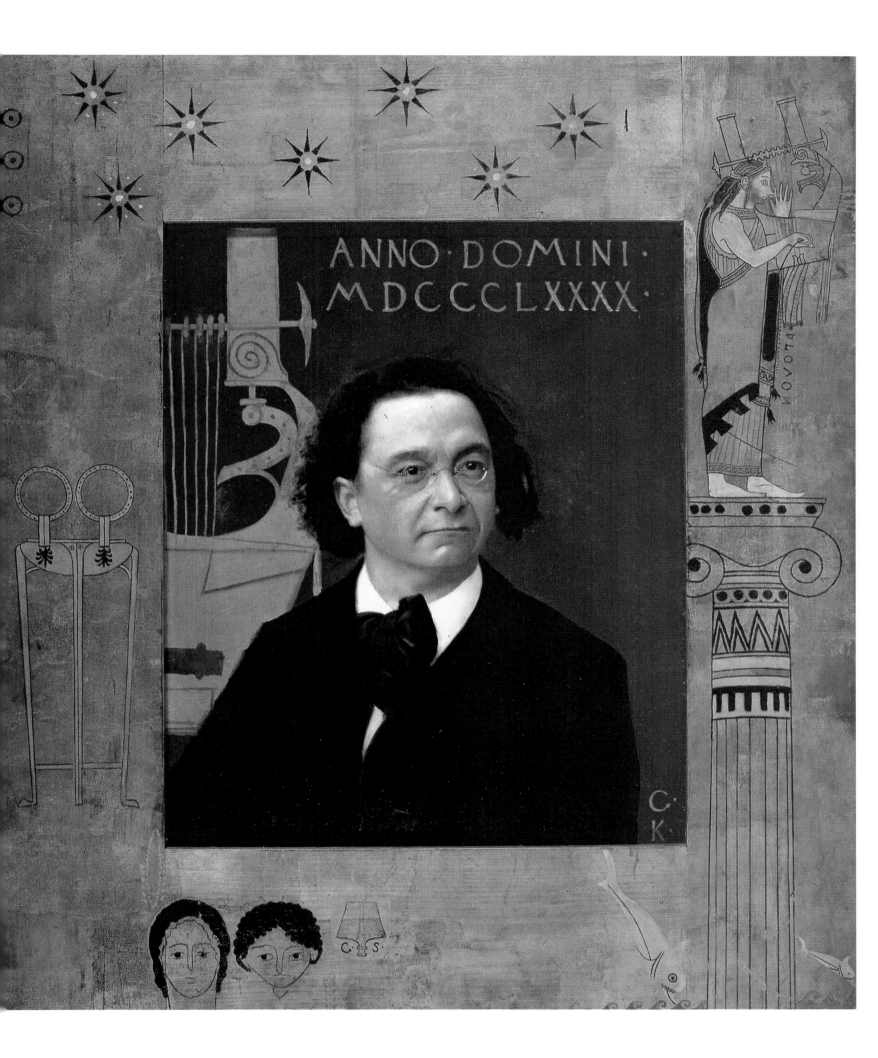

ANNO · DOMINI ·
MDCCCLXXXX ·

ANCIENT GREEK ART I

1890-91
Kunsthistorisches Museum, Vienna

Klimt's position as the successor to Makart was yet more clearly established when he inherited the commission to complete the decorations of the staircase of the *Kunsthistorische Museum* which had been left unfinished when Makart died in 1884. Gustav, Ernst Klimt and Franz Matsch provided 40 paintings illustrating the development of art from ancient Egypt, until the Renaissance, in order to decorate the spandrels and the awkward narrow, vertical spaces between the columns. In the eleven panels painted by Gustav Klimt himself between 1890 and 1891, we have the first intimations of his impending break with academic orthodoxy and of the direction he would move in by the end of the decade. The very awkwardness of the panel shapes which did not lend itself to an effective representation of spatial recession may have encouraged Klimt to paint in a flatter and more compressed and stylised manner. For the first time we see that juxtaposition of almost photographically rendered elements (notably the faces) with flat, decorative backgrounds. For the first time too Klimt moved on from the passive and rather bovine feminine ideal of academic art, to a female type with some of the "femme fatale" allure that characterises his later depictions of woman.

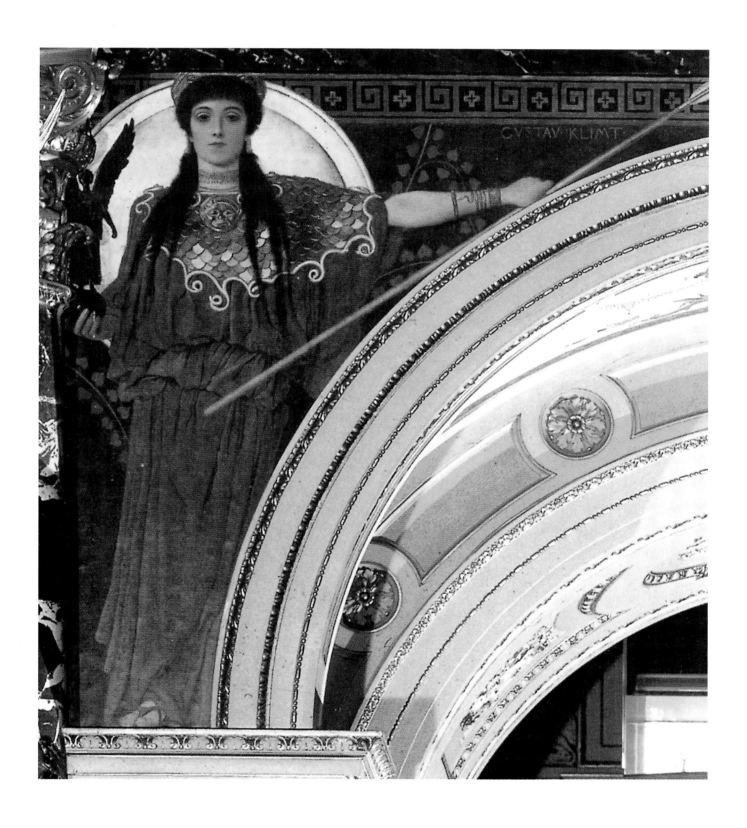

LOVE

1895
Oil on canvas
60 x 44 cm
Historisches Museum, Vienna

The theme of an embracing couple would be dealt with more memorably by Klimt on several later occasions, most notably in his design for the mosaic frieze in the Palais Soclet, in the Beethoven Frieze and above all in what became his most popular work *The Kiss* of 1907-9.

In 1895, when Klimt painted this delicate picture, it was a mere two years before the founding of the Vienna Secession and Klimt's own sudden transformation from a conservative academic painter into the standard bearer of the Viennese avant-garde. But Klimt's treatment of the embracing figures is still essentially academic and surprisingly unadventurous. In the sinister floating figures at the top of the canvas we have an interesting foretaste of the Vienna University ceilings as well as of the Beethoven Frieze. The frame, with its extensive use of flat gilding, the asymmetrical and cropped placing of the roses, shows clearly that Klimt was already intrigued by the principles of Japanese design, though the roses themselves have cabbage-like Western three-dimensionality.

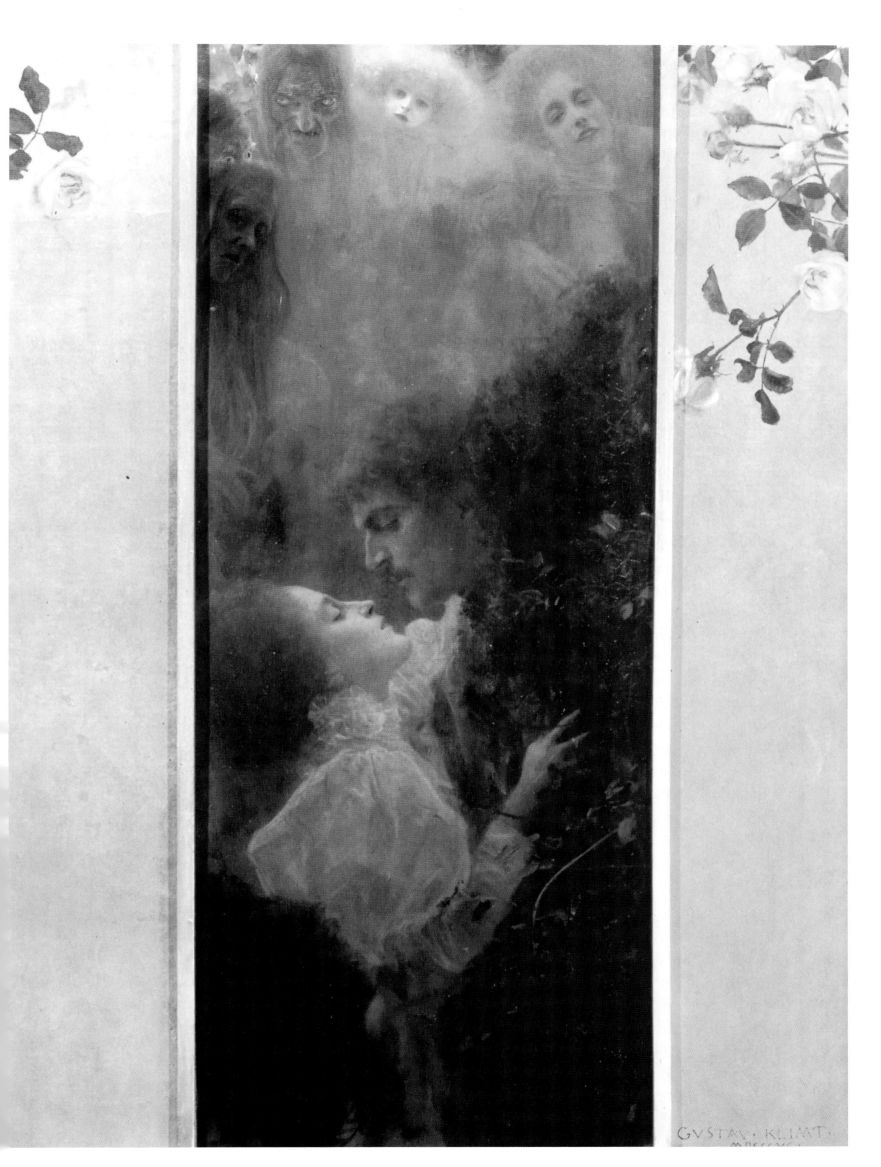

TRAGEDY (PUBLISHED AS N° 66 IN ALLEGORIEN NEUE FOLGE)

1897
Black crayon, graphite washes with gold
41.9 x 30.8 cm
Historische Museum, Vienna

Fourteen years after the publisher Martin Gerlach gave him his first major opportunity by commissioning designs for his *Allegories and Emblems* pieces, he returned to Klimt for a second set of designs that were produced between 1895 and 1897. A comparison between *Fable* of 1883 and *Tragedy* of 1897, this work highlights the remarkable transformation that had taken place in Klimt's work. The two designs could be by quite different artists. The sinister beauty of the tragic muse Melpomene, shows Klimt's interest in the Belgian Symbolist Fernand Khnopff, then at the height of his fame. The gilded collar that appears to sever Melpomene's head from her body and which would become such a feature of Klimt's depiction of women over the next few years, was also originally derived from Khnopff.

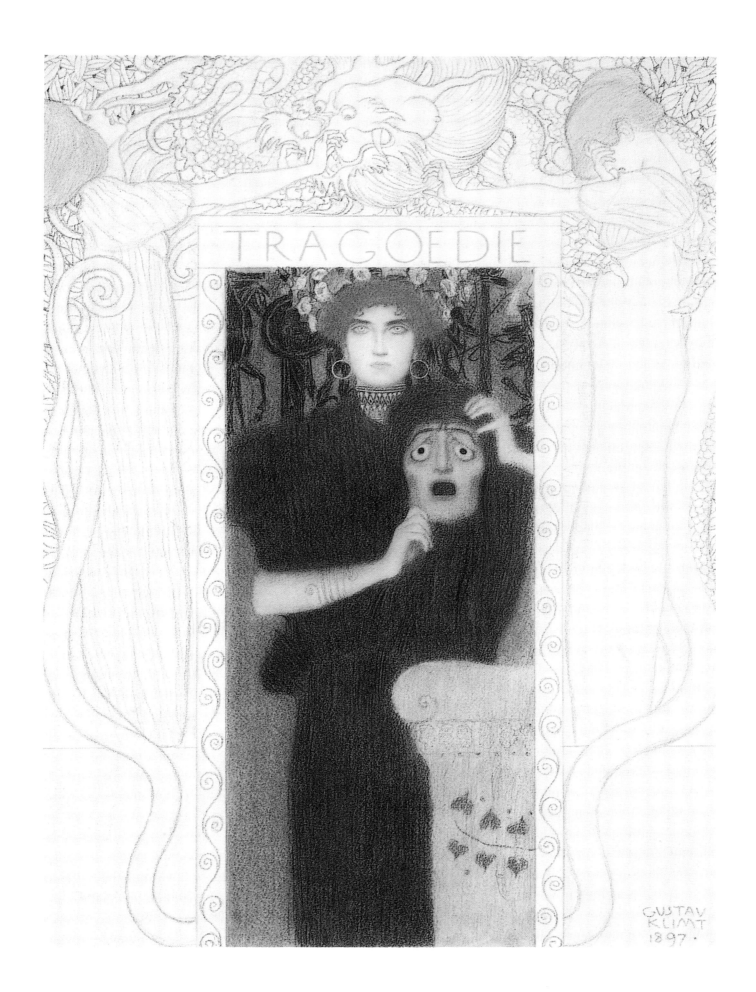

MUSIC I

1895
Oil on canvas
37 x 45 cm
Neue Pinakothek, Munich

Music was the most widely loved of the arts in Vienna at the turn of the century. Vienna was still regarded as the musical capital of the world. It was the city of Mozart, Beethoven and Schubert and more recently of Brahms, the Strauss family, Bruckner and Mahler. In 1897 Gustav Mahler took over the direction of the Imperial Opera and brought something new to the musical life of Vienna in much the same way that the founding of the Secession did in the same year. Mahler's provocative declaration "Tradition is sloppiness" paralleled the more elegantly phrased motto "To every age its art, to art its freedom" that adorned the façade of the new Secession building. *Music I* of 1895 is stylistically far in advance of *Love* painted in the same year. Indeed *Music I* was one of Klimt's first exercises in the manner shortly to be dubbed the "Secession style". A second version of three years later was paired with *Schubert at the piano* to decorate the music room of the Palais Dumba.

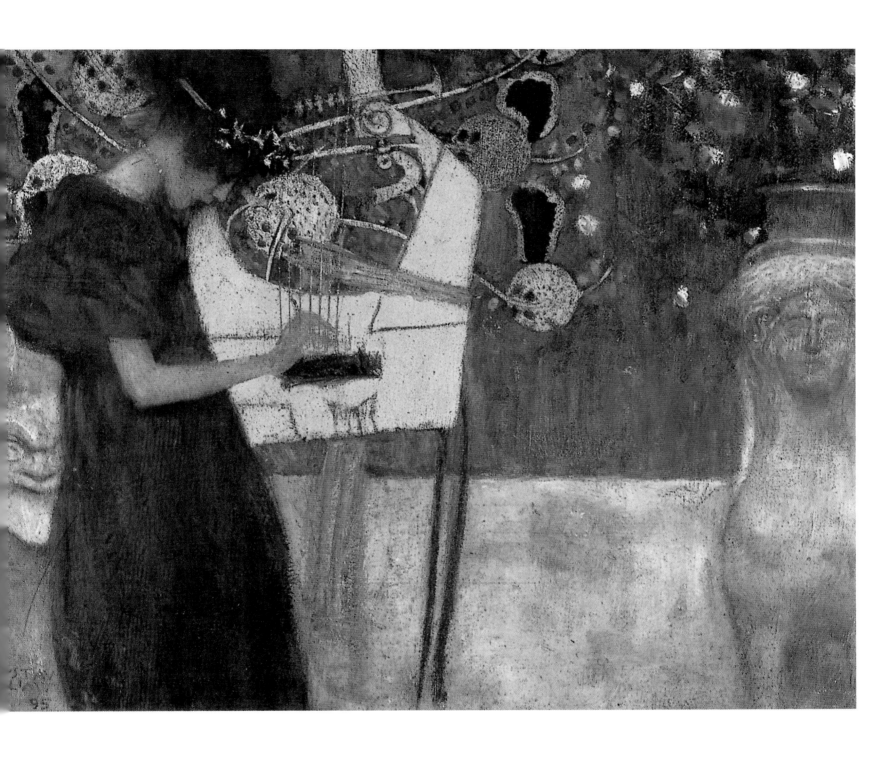

COMPOSITIONAL SKETCH FOR MEDICINE

1897-8
Graphite
72 x 55 cm
Vienna

Apart from photographs and preparatory drawings this is all that remains as evidence of the appearance of the first of the three great ceiling paintings for the University of Vienna that were amongst Klimt's greatest achievements. In 1891 following the much acclaimed success of the decorative schemes for the Burgtheater and the Kunsthistorischesmuseum, Klimt and Franz Matsch were commissioned to paint a series of monumental panels to decorate the great hall of the University of Vienna. Matsch was to paint the central panel representing *The Victory of Light over Darkness* and a panel representing *Theology* (presumably this subject was thought unsuitable for the notoriously hedonistic Klimt). Klimt undertook the painting of the three remaining panels to symbolise the university faculties of philosophy, medicine and jurisprudence. When the first of the panels *Philosophy* was exhibited in 1900, the mature Klimt was revealed to the world on a monumental scale for the first time. Though the panel was warmly praised and won a gold medal when it was exhibited at the 1900 Paris world fair, conservative Vienna proved less understanding of the new direction in which Klimt was travelling. The second panel *Medicine* caused outrage when it was exhibited in 1901, with its disturbing eroticism and its blatant depiction of female pubic hair (something quite unprecedented in Western art in a public work of this nature).

In response to the continuing controversy, Klimt eventually paid back his advance from the University and retained ownership of the three paintings. Tragically, in one of the great artistic losses of the Second World War, the panels were destroyed when Schloss Immendorf, where they were being stored for safety was deliberately burned by the retreating SS troops.

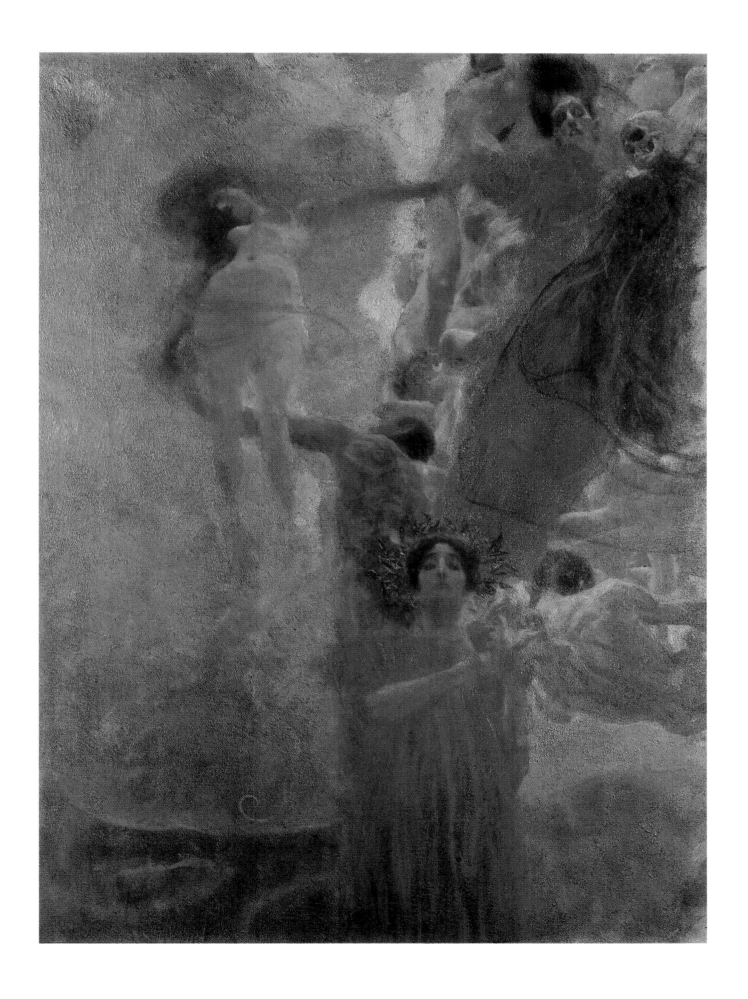

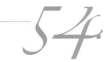

PALLAS ATHENA

1898
Oil on canvas
75 x 75 cm
Historisches Museum, Vienna

Around the turn of the century, many leading cultural figures in German speaking countries showed renewed and intense interest in ancient Greek culture and mythology, from Freud and Hofmannsthal through to the composer Richard Strauss and the painters Franz von Stuck and Gustav Klimt. They were looking for profound and universal meanings in an ancient culture in which the entire Western tradition had its origins. One of the first examples of Klimt's fully developed "Secession" style, *Pallas Athena* was shown at the second exhibition of the Vienna Secession in 1898. It brings Klimt close to his Bavarian contemporary Franz von Stuck who was the dominant figure of the Munich Secession that preceded that of Vienna by four years. Stuck also depicted Athena amongst many other Greek subjects. With many stylistic elements in common as well as careers that paralleled one another in their respective cities, Klimt and Schiele were inevitably compared. Hofmannsthal was convinced that Stuck's was the more profound and genuine talent and that Klimt was merely meretricious and modish. He would no doubt have been surprised to see how time has reversed this judgement.

The sculptured frame which is integral to the picture was designed by Klimt and made by his brother Georg.

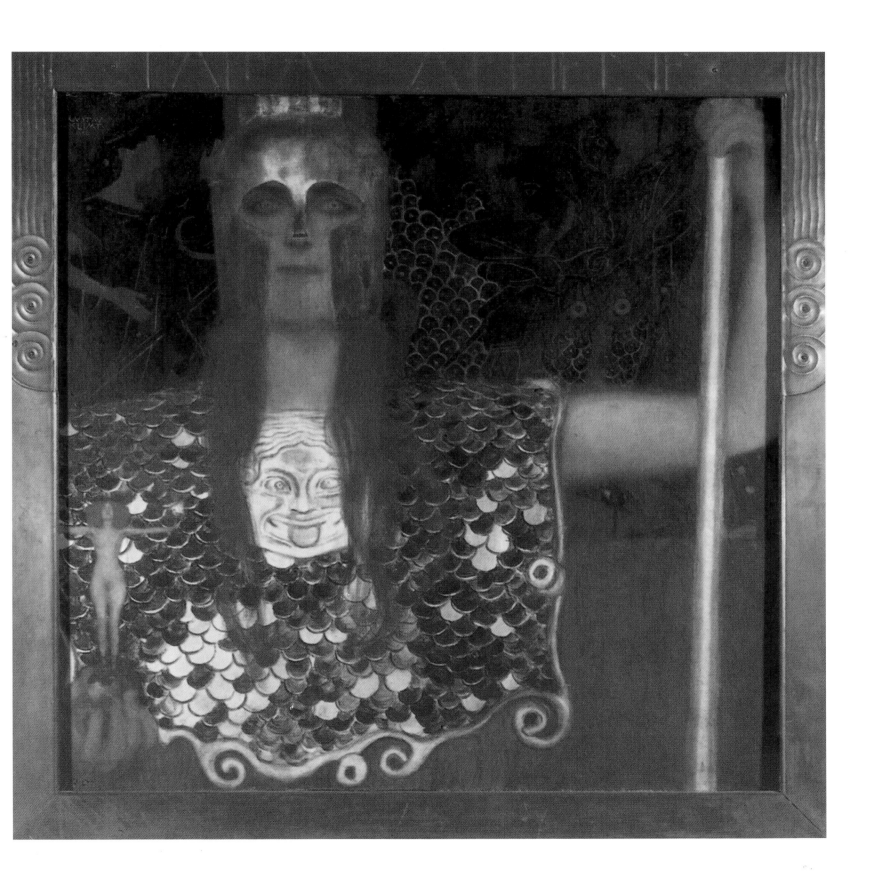

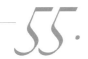

PORTRAIT OF SONJA KNIPS

1898
Oil on canvas
145 x 145 cm
Österreichische Galerie, Vienna

The portrait of Sonja Knips was shown at the second exhibition of the Vienna Secession in 1898 and was an early example of Klimt's remarkable ability to synthesise disparate stylistic elements into something utterly individual and distinctive. The dominant influences here are from Japanese woodblock prints and from Whistler (an artist who had already shown how to incorporate Japanese elements into Western portraits). The Japanese influence is apparent in the startling asymmetry of the composition, the use of empty spaces as positive compositional elements (notably in the spaces between the sitter's arms and torso as well as the large empty space on the left of the picture) and the strange intrusion of flowers into the picture space from the left and the right. Klimt could have seen a similar use of flowers in Whistler's portrait of Cecily Alexander. Whistler's influence also shows itself in the delicately muddy, soft focus technique and in the muted and exquisite colour harmony. The sweet femininity of the sitter is counteracted by features that introduce elements of tension into the picture, such as the suggestion of a grotesque mask in the background, the tense claw-like pose of her left hand on the arm of the chair and the mysterious little red book she holds so tentatively in her right hand.

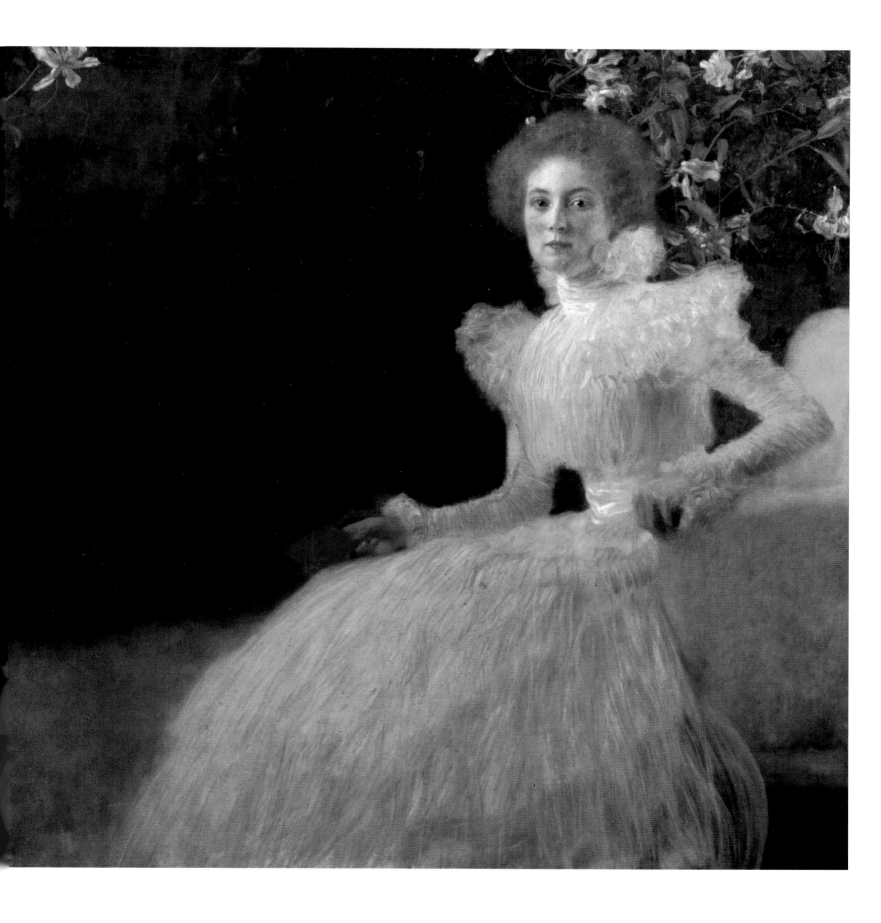

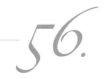

POSTER FOR THE FIRST EXHIBITION OF THE VIENNA SECESSION

1898
lithography
62 x 43 cm
Private Collection

James McNeill Whistler ended his famous "Ten o'clock lecture" with the ringing declaration that the story of beauty is complete "written in the marbles of the Parthenon and embroidered on the fan of Hokusai". The challenge of this strange juxtaposition of ancient Greece and Japan is taken up in this poster which combines profile figures inspired by Greek vase painting with an extreme asymmetry and a use of empty space derived from Japanese woodblock prints. The subject of the slaying of the Minotaur by Theseus may be read as intended to represent the struggle of the Vienna Secession against the forces of philistinism and conservatism. Viennese officialdom struck back by forcing Klimt to censor the conspicuously displayed genitalia of Theseus. In a second version of the poster, Klimt complied with the censorship, but not by falling back on the cliched device of the fig leaf. Instead, he cheekily and ingeniously introduced a further Japanese design element with an asymmetrically placed tree trunk that conveniently covered the offending parts.

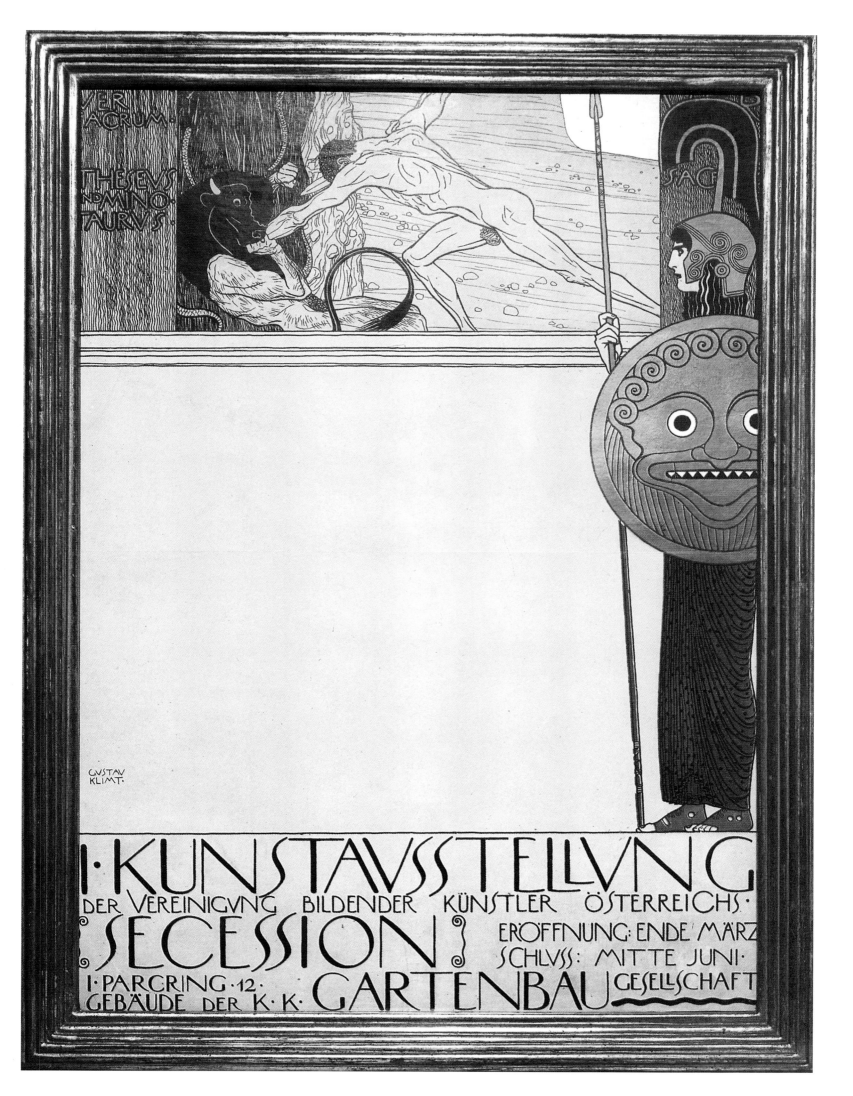

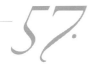

NUDA VERITAS

1899
Oil on canvas
252 x 56.2 cm
Theatersammlung der Nationalbibliothek,
Vienna

In *Nuda Veritas*, which was exhibited at the fourth exhibition of the Vienna Secession in March 1899, we see brought together all the elements that we associate with the Secession style. Klimt finally achieved a satisfactory synthesis of naturalistic and abstract, decorative elements. The text on the gilded ground and the surrounding frame are integral to the composition. The frontally posed nude with her halo of fiery hair, her somewhat sinister allure and her explicitly depicted pubic hair conform to what would be from now on Klimt's feminine ideal.

The image of naked truth and the provocative quote from Schiller, "If by your actions and your art you cannot please everyone – please a few. To please everyone is bad", refers not only to Klimt's rejection of the hypocrisy of conservative Vienna, but also according to Klimt's friend Bertha Zuckerkandl, expresses his response to the contemporary struggle for truth in France by the supporters of the unjustly accused Captain Dreyfus. As Klimt's major patrons and supporters were almost exclusively Jewish, it is hardly surprising that Klimt should have sympathised with the Dreyfusards. It was the Dreyfus Affair that shocked the Viennese journalist Theodor Herzl into abandoning his hopes for the assimilation of Jews into European society and inspired his call for the founding of a Jewish state.

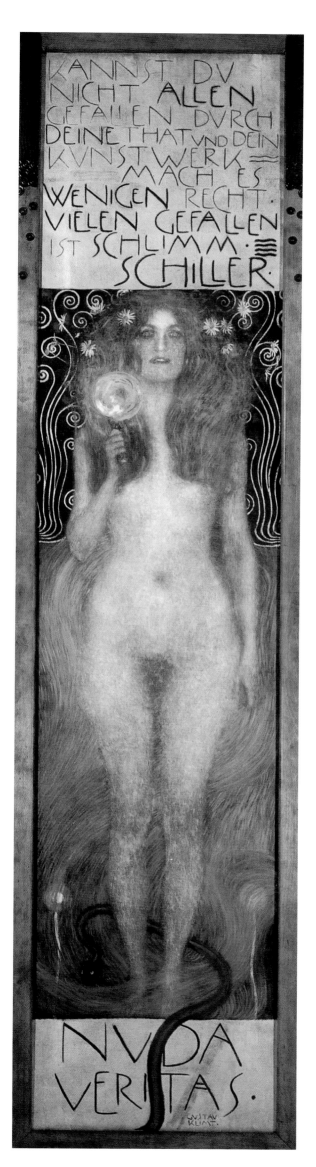

KANNST DV
NICHT ALLEN
GEFALLEN DVRCH
DEINE THAT VND DEIN
KVNSTWERK —
MACH ES
WENIGEN RECHT.
VIELEN GEFALLEN
IST SCHLIMM.
SCHILLER.

NVDA
VERITAS.

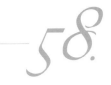

SCHUBERT
AT THE PIANO

1899
Oil on canvas
200 x 150 cm
Burned in Schloß Immendorf, Austria, 1945

Schubert at the Piano was commissioned to decorate the music room in the Palais Dumba. The elongated, horizontal format of the picture indicates that like its pendent *Music II*, it was intended to be placed above a door. Though the high waistlines of the young women's dresses follow the fashion of the early nineteenth century Biedermeier period in which Schubert lived, their facial types and hair styles are very much of Klimt's own time.

The patterned broken brushwork Klimt has used in this picture indicates his familiarity with the Neo-Impressionist techniques of Seurat and his followers but is used somewhat differently to create a flatter more decorative effect. This charming picture which was amongst the most popular and succesful of Klimt's works during his lifetime, was, like the University cielings, lost in the conflagration at Schloss Immendorf in 1945.

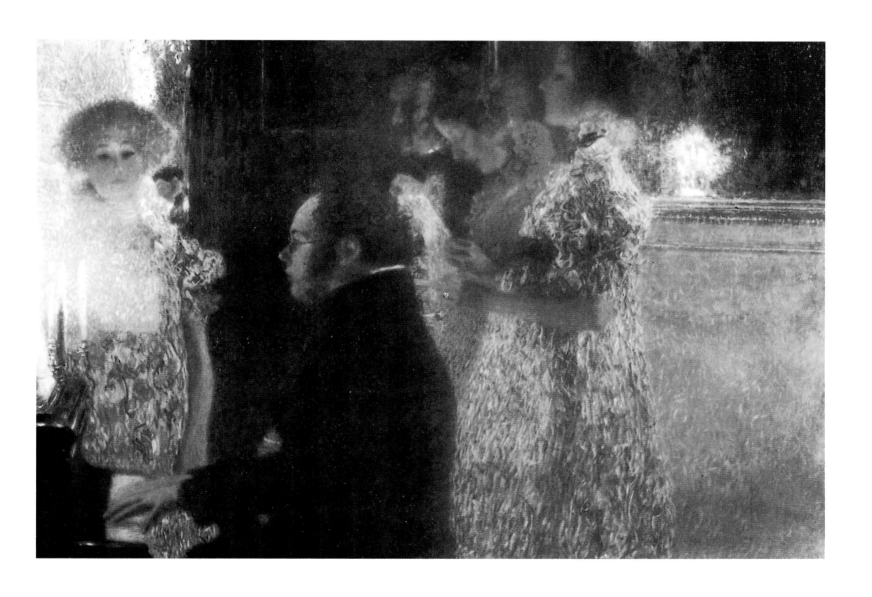

THE BEETHOVEN FRIEZE

1902
Casein on plaster
H. 220 cm
Secession, Vienna

By default, following the tragic destruction of the Vienna University ceilings, the *Beethoven Frieze* has become Klimt's most important surviving work. Indeed the unexpected and near miraculous survival of this vast and fragile work painted on plaster that was never meant to be permanent, makes up to some extent for the losses of the Second World War.

The Beethoven Frieze was intended as a backdrop for Klingers ten foot high polychrome sculpture of Beethoven that was shown at the fourteenth exhibition of the Vienna Secession in 1902. A near contemporary of Klimt and Stuck, Max Klinger is chiefly admired today as a quirkily original print-maker. His paintings paralleled those of Klimt in attempting to combine elements of disparate styles, but are far less successful in synthesising the mythological subject matter and heavy symbolism of Bocklin with the plein-air palette of the Impressionists.

The Beethoven statue, once regarded as one of the peaks of Western art, now seems more of a monument to bad taste and megalomania than to Beethoven. Its overblown monumentalism is disturbingly prescient of the art of the Third Reich.

Klimt's Frieze pays little deference either to Klinger or indeed to Beethoven. Instead Klimt explores his standard theme of human and above all female sexuality.

TWO LOVERS

1901-1902
Study for the *Beethoven Frieze*,
Black pencil
45 x 30.8 cm
Vienna

This drawing is a study for the section of the *Beethoven Frieze* entitled somewhat euphemistically "The Yearning for Happiness finds Fulfillment in Happiness". Ostensibly this section of the Frieze connects with Schiller's "Ode to Joy" sung by soloists and full chorus in the last movement of Beethoven's "Ninth Symphony". The floating virgins lined up on either side of the embracing couple in the Frieze might be seen as representing Beethoven's chorus.

As in *The Kiss* painted several years later, the abstract, decorative surround of the couple suggests fairly explicitly the form of an erect phallus within the surrounding vagina. In the painting itself, the veil surrounding the feet of the couple adds to the piquancy by emphasising their nakedness and the urgency of their embrace. The male nude is a rare exception in Klimt's art. The rippling musculature of his back is somewhat reminiscent of the back of the male figure in Rodin's scupture *The Kiss*.

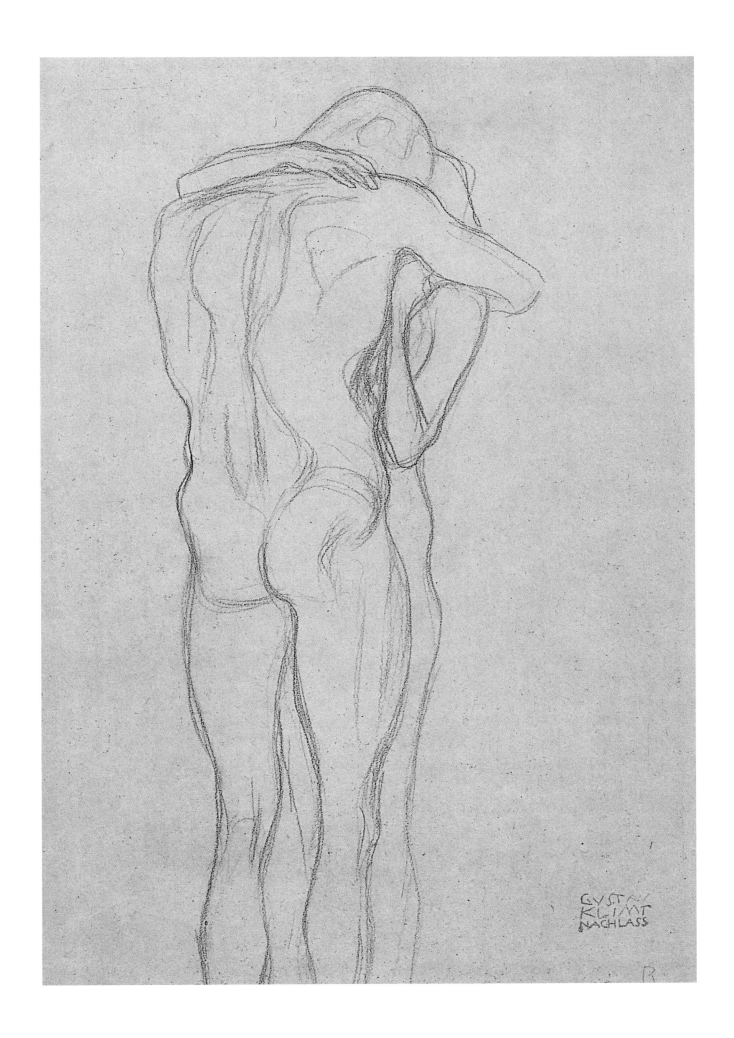

ISLAND IN THE ATTERSEE

c.1901
Oil on canvas
100 x 100 cm
Private collection

For over twenty years Klimt enjoyed spending the summer months with his lover Emilie Flöge and her family by the Attersee. A great lover of boating, Klimt, like Monet before him enjoyed the luxury of painting nature from the undisturbed privacy of a boat, though Klimt was never as concerned as Monet or Sisley with the direct transposition of nature onto the surface of the canvas. The composition of this picture suggests that it may have been painted on, rather than beside, the Attersee. The luminous palette of colours and the use of broken brushwork to render the shimmering surface of the water, show Klimt's knowledge of Monet's work even before it was shown at the Secession in 1903. The oriental compositional device of the extremely high horizon line, used to flatten space, was also used by Monet in the later stages of his career.

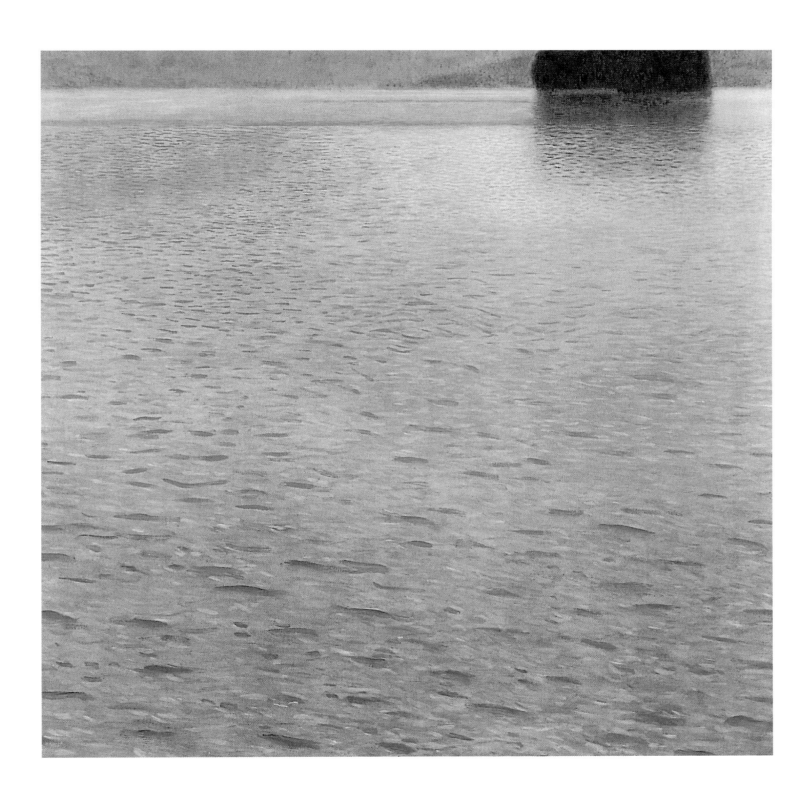

GOLDFISH

1901-2
Oil on canvas
181 x 66.5 cm
Galleria d'Arte Moderna, Venice

Goldfish presents female sexuality as something at once fascinating and menacing. The smiles of the floating women are both enticing and chilling. Their coquettishness is reminiscent of the Rhinemaidens in the opening scene of Wagner's *Das Rheingold*. They are all endowed with an abundance of flowing hair – the ultimate weapon of seduction. At a time when respectable women kept their hair up and under careful control in public situations, the sight of such free-flowing hair held connotations of the loss of inhibitions and unbridled sexuality. In the late nineteenth century and up to the First World War artists such as Dante Gabriel Rossetti, Burne-Jones, Beardsley, Waterhouse, Degas, Munch, Mucha, Toorop and Klimt himself, indulged in fetishistic fantasies of women's hair.

Just as hair could be used to envelop, entrap and even suffocate or strangle, water too had connotations of dangerous sexuality and drowning and was often associated with Femmes Fatales and sirens.

The elongated vertical format of this painting, foreign to the Western tradition, derives ultimately from Chinese scroll painting via Japanese woodblock prints.

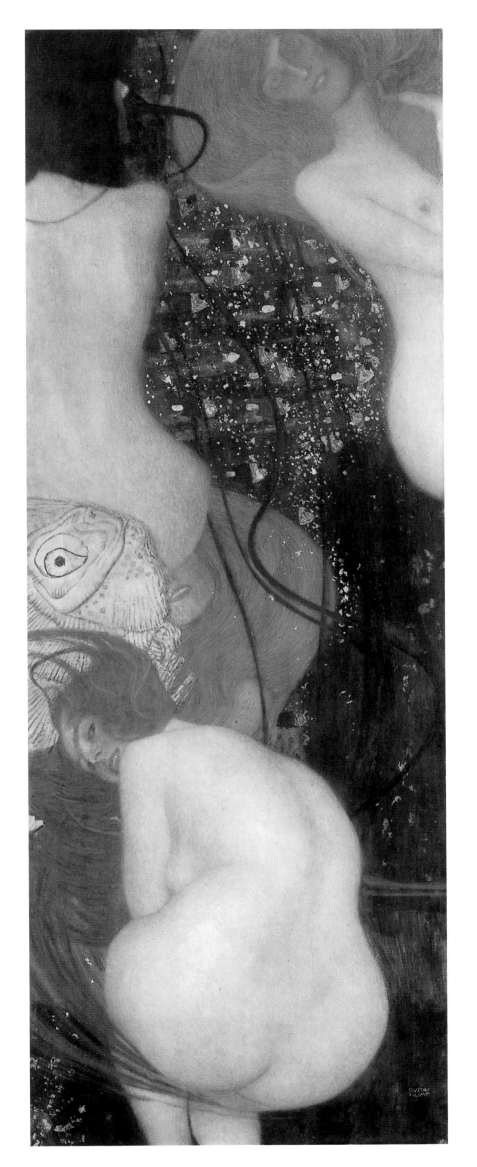

63.

JUDITH I

1901
Oil on canvas
84 x 42 cm
Österreichische Galerie, Vienna

The Biblical heroine Judith saved the Jewish people by seducing and slaying the Philistine general Holofernes. Renaissance artists such as Donatello used her as an archetype of patriotism and female courage. In the seventeenth century, Baroque artists such as Caravaggio, Johannes Liss and Artemesis Gentileschi began to explore the psycho-sexual possibilities of the subject, but it was not until the late nineteenth century that Judith was elevated, alongside Salome, to the status of a fully-fledged Femme Fatale. Amongst the other artists of this period who depicted Judith in the role of Femme Fatale were Franz von Stuck, and Gustave Mossa. Klimt's *Judith I* of 1901 is perhaps the most powerful and disturbing of all his depictions of menacing female sexuality. With her raised head, crowned by an abundance of hair, her strong chin, half-closed eyes and parted lips creating an expression of ecstasy, Klimt's *Judith* descends (perhaps via the Belgian symbolist Fernand Khnopff) from Dante Gabriel Rossetti's influential *Beata Beatrix*. She is also related to Munch's *Madonna* and the girl in Mucha's Job poster, though the ecstasy of Mucha's young lady is prompted by nothing more sinister than a drag on a cigarette. The jewelled collar that appears to sever Judith's own head is also a feature of many of Klimt's portraits of these years.

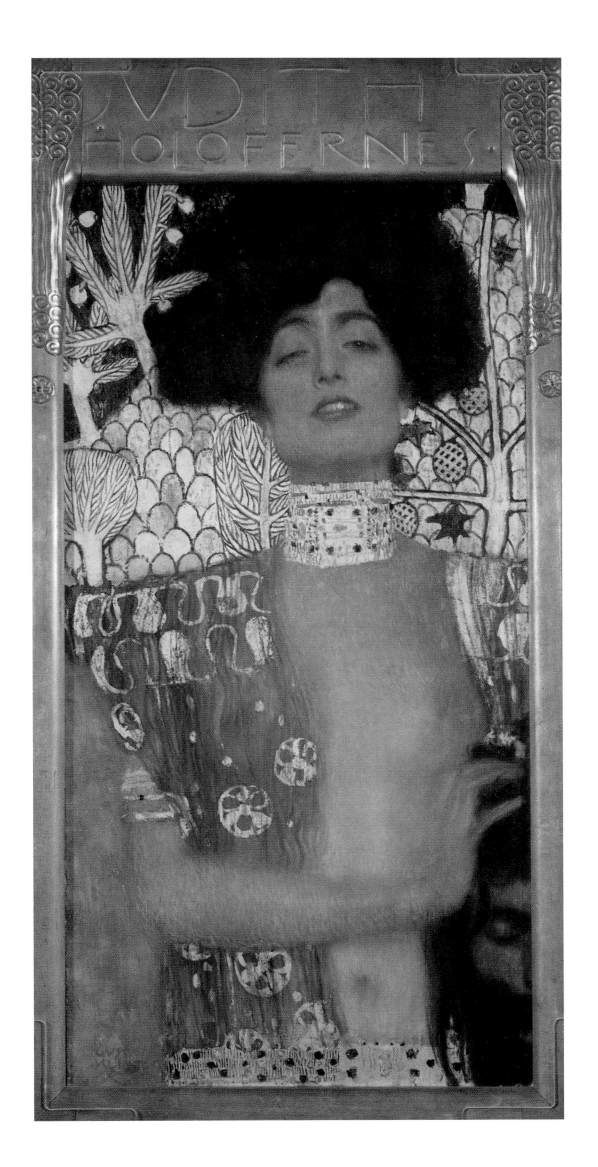

PORTRAIT OF EMILIE FLÖGE

1902
Oil on Canvas
181 x 84 cm,
Historisches Museum, Vienna

Klimt never married and by all accounts does not seem to have been bound by conventional concepts of sexual fidelity, but nevertheless maintained a long-term relationship with Emilie Flöge that lasted until his death. Emilie Flöge and her sisters (one of whom was married to Klimt's brother Ernst) ran a fashion house in Vienna called the Casa Piccolo. As a believer in the Arts and Crafts doctrine of the unity of fine and decorative arts inherited from William Morris and practised by other contemporary artist designers such as Henri van de Velde and Charles Rennie Mackintosh, Klimt was happy to work in Emilie Flöge's fashion business and did not regard the designing of dresses, textiles and even labels as being beneath him. Emilie Flöge's loose but streamlined gown is very different from the tightly corseted look of Sonja Knips' dress painted four years earlier and still visible in well-known photographs of fashionable ladies visiting the Vienna *Kunstschau* in 1908. Emilie's sumptuous gown lies somewhere between the aesthetic garb of the Pre-Raphaelite women and the revolutionary corset-less designs produced by the Parisian couturier Paul Poiret after 1908. The use of silvered geometric elements marks the beginning of Klimt's Byzantine or "golden" style that would reach a climax five years later with his first portrait of Adele Bloch-Bauer.

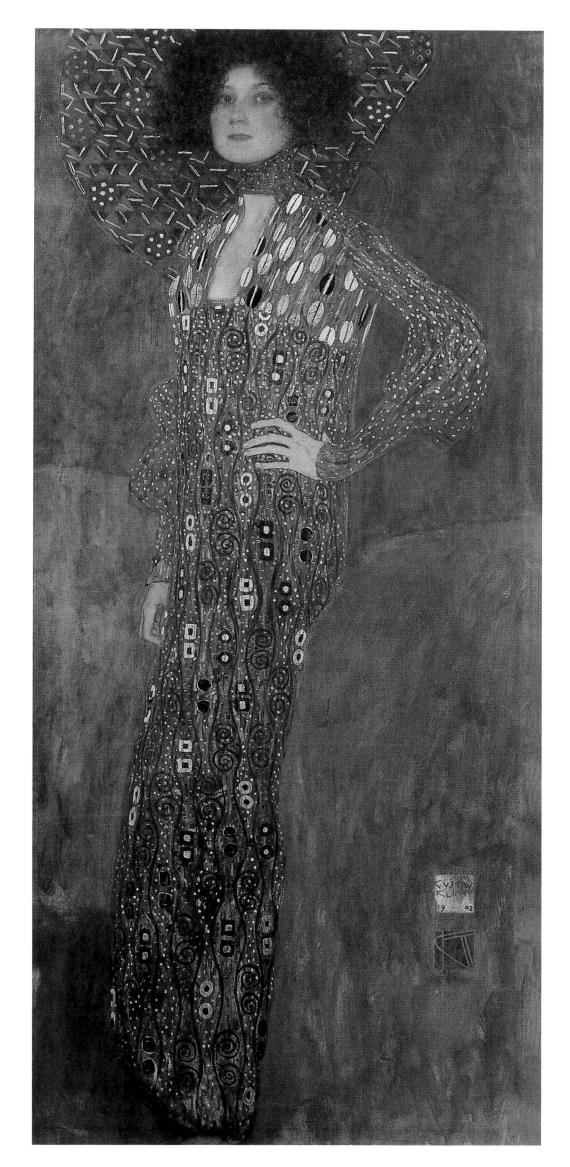

FOREST OF BEECH TREES I

c.1902
Oil on canvas
100 x 100 cm
Moderne Galerie, Dresden

After 1900 Klimt turned increasingly to landscape as a subject. Altogether he painted well over fifty of them, very few preparatory studies exist for these landscapes and it seems that he followed the Impressionist practice of painting outdoors and directly from the subject, usually during his summer holidays. Unlike Impressionist paintings of the 1870s, Klimt's landscapes are far from being spontaneous transcriptions of what his eyes saw at a particular place and moment. In Klimt's landscapes there is always a strong element of pattern-making abstraction. *Beech Trees* uses the device of a screen of tree trunks cropped at the top and bottom of the canvas, borrowed perhaps from Monet's Poplar series, and that Monet himself had taken from Japanese wood block prints.

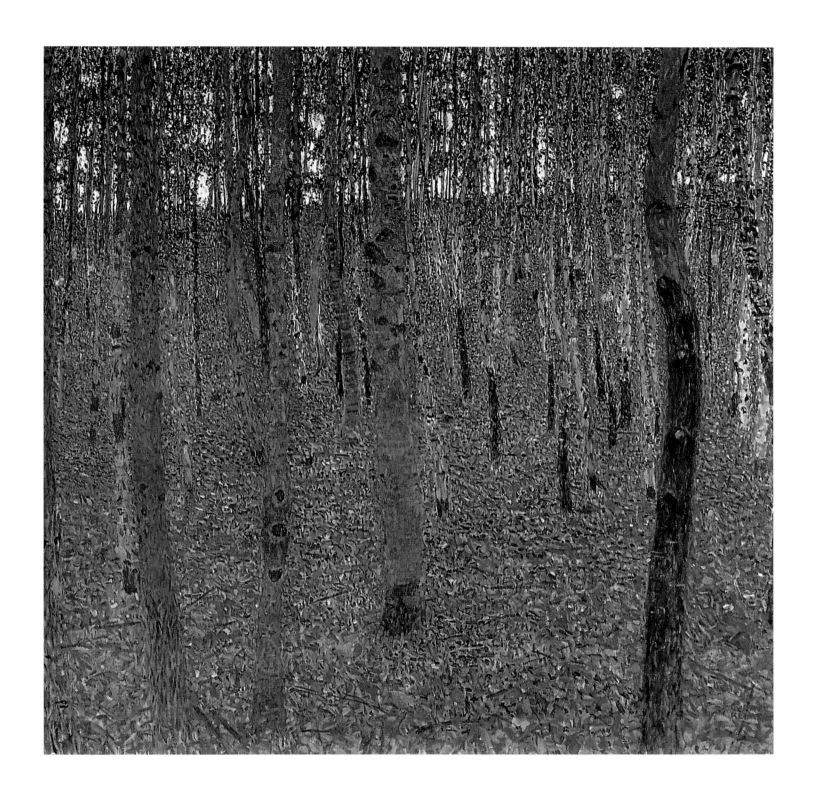

HOPE I

1903
Oil on canvas
189 x 67 cm
National Gallery of Canada, Ottawa

The form of a nude pregnant woman with the skin stretched across the rounded womb is surely one of the most beautiful and satisfying for any painter or sculptor and it is strange that there should have been a taboo in Western art on the representation of pregnancy. Klimt was one of the first artists to break this taboo. In 1908 there was a major scandal when Jacob Epstein sculpted a semi-nude pregnant woman to fill a niche on the exterior of the British Medical Association building in London. Even Klimt did not dare to show this painting publicly until the second Vienna *Kunstschau* in 1909 by which time he presumably hoped that the Viennese public had been sufficiently softened up by the shocking innovations of his younger contemporaries, Schiele, Kokoschka and Gerstl.

Despite the title, the meaning of this painting is by no means entirely optimistic. As in Munch's print *Madonna*, the themes of conception and birth are intertwined with those of decay and death represented by the row of sinister heads at the top of the picture.

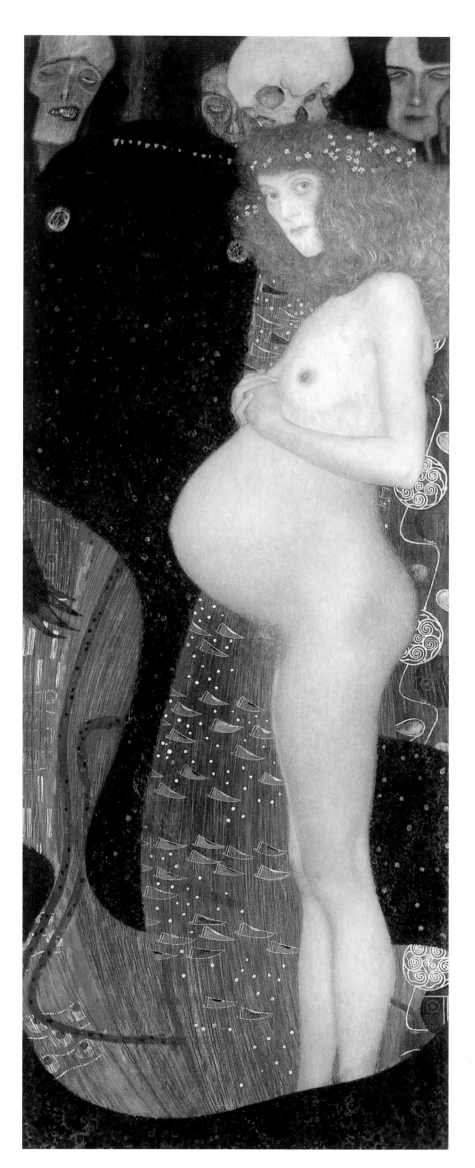

WATER SNAKES I

1904-7
Watercolour
50 x 20 cm
Österreichische Galerie, Vienna

Klimt's frank exploration of female sexuality makes him seem very modern. But there are many ways in which his art is firmly rooted in the nineteenth century. It is enough to remember that in 1907, the year Klimt completed this exquisite and precious work on parchment, that Picasso was working on that cornerstone of Modernism *Les Demoiselles d'Avignon (the Young Ladies of Avignon)* to realise that the visual language that Klimt used to the end of his life, was essentially that of the *fin de siècle*. The theme of the mermaid or siren was a popular one in nineteenth century art, literature and opera. Klimt would have been very familiar with Arnold Bocklin's paintings of frolicking mermaids that were immensely famous in the German speaking world, though Böcklin's *hausfrau*-like sirens are very different from Klimt's svelte and alluring creatures.

The extreme and anatomically impossible torsion of the upper mermaid's neck is a feature found in several of Klimt's paintings such as *The Kiss*, *The Virgin* and the unfinished *The Bride* and seems to denote ecstasy.

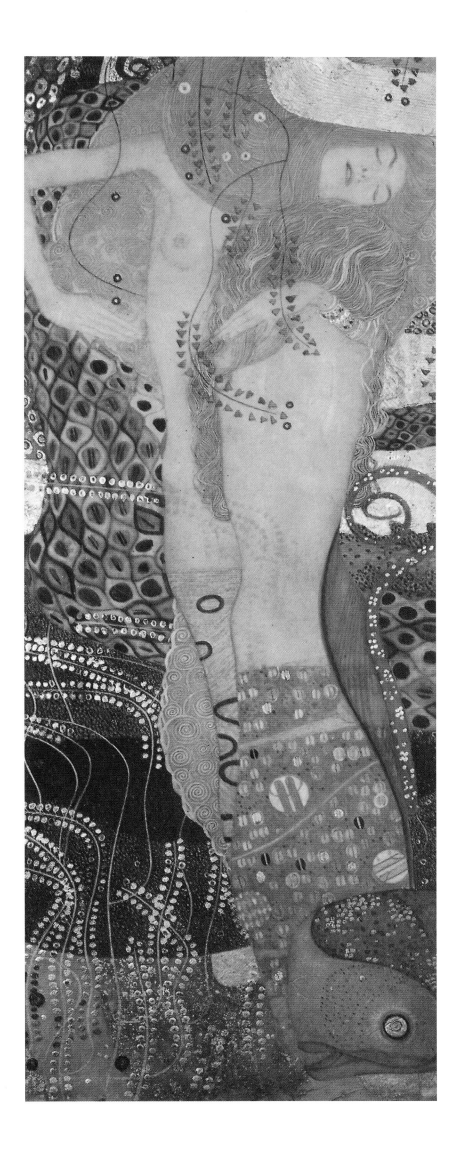

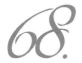

WATER SNAKES II

1904-1907
Oil on canvas
80 x 145 cm
Private Collection

For many viewers in the early 1900s the most shocking feature of this picture, as well as of *Hope I* would have been Klimt's unabashed depiction of the golden haze of pubic hair. Female pubic hair was one of the great unmentionable and unrepresentable subjects of the Nineteenth Century and indeed had hardly ever been depicted in Western art before Klimt, outside of pornography. It was a topic of intense interest to nineteenth century male libertines as we know from the Paris guide books for sexual tourists that describe the pubic hair of available women in the most specific anatomical detail.

As early as the 1860s Courbet had painted a close up view of the unwaxed female pudenda that he entitled *L'Origine du Monde (The Origin of the World)* but this was made for the private delectation of a Turkish collector of erotica rather then for pubic exhibition.

After a lifetime of studying Western art, the British historian and critic John Ruskin was so disconcerted to discover on his wedding night that women also have pubic hair that he was unable to consummate the marriage. After 1900, thanks to Klimt, this was not a problem likely to afflict Viennese art lovers.

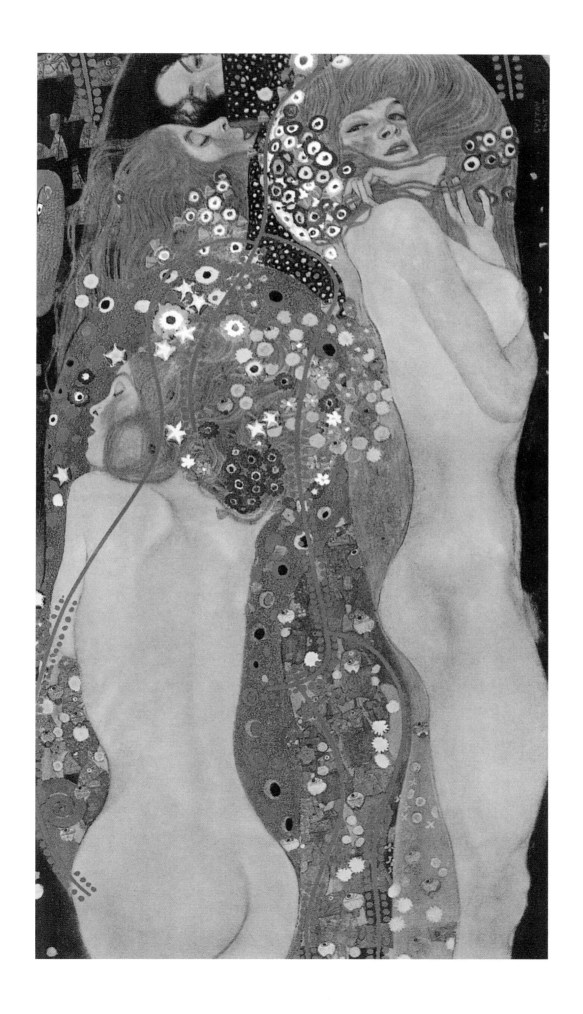

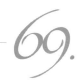

THE THREE AGES OF WOMAN

1905
Oil on Canvas
178 x 198 cm
Galleria Nazionale d'Arte Moderna, Rome

The ageing process and in particular that of women was a traditional subject and had been depicted by Renaissance artists such as Hans Baldung Grien and Giorgione. The human life cycle was a common pre-occupation of artists of the Symbolist era. Klimt would have been familiar with Arnold Böcklin. 1888 painting *Vita somnuium breve* that deals with the stages of life from babyhood to death and also with Munch's 1894 *The three Stages of Woman* that deals somewhat misogynistically with the three aspects of woman as virgin, whore and death rather than with the ageing process as such. Klimt's tender and painfully honest treatment of the aged woman is perhaps the most remarkable feature of this picture. He may have been inspired by Rodin's moving depiction of the frailty of age in his small bronze entitled, *She who was once the Helmet-Maker's Beautiful Wife.* Fourteen of Rodin's sculptures were included in the tenth exhibition of the Vienna Secession in 1901. Though Klimt would later develop a looser and more painterly technique, his careful delineation of the complex, knotty anatomy of the old woman and the hatched shading of her concave buttock, show that he was always essentially a draughtsman who painted, rather than a lover of *Belle Peinture* for its own sake.

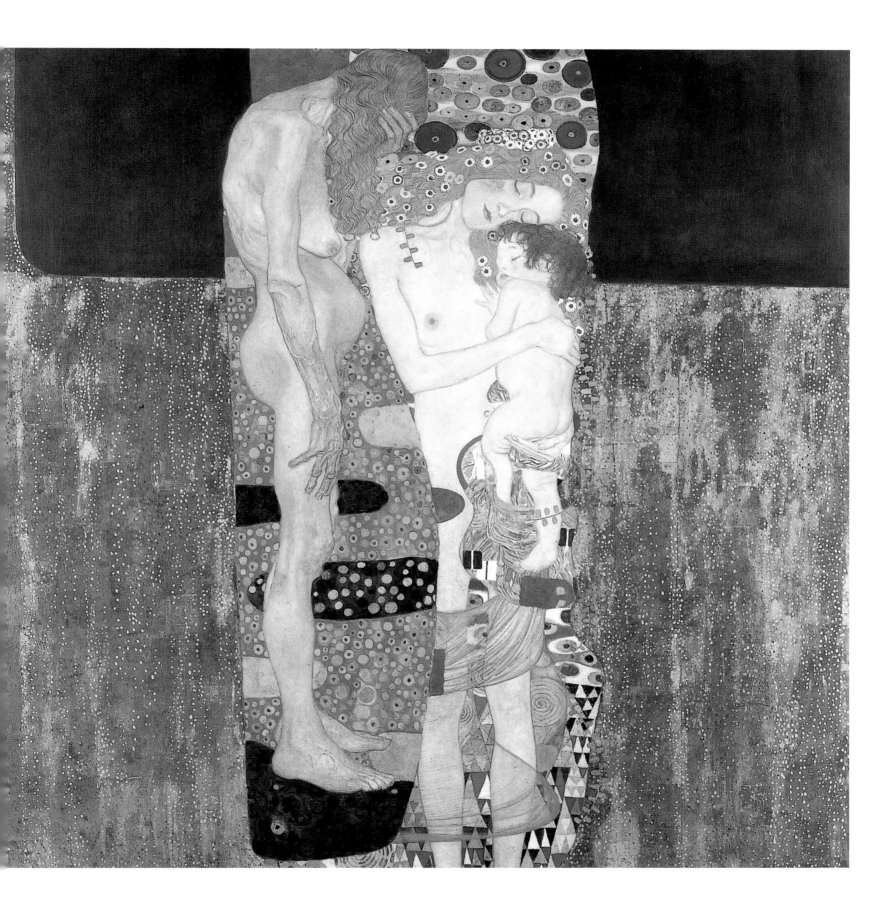

PORTRAIT OF MARGARET STONBOROUGH-WITTGENSTEIN

1905
Oil on Canvas
180 x 90 cm
Neue Pinakothek, Munich

Margaret Stonborough-Wittgenstein belonged to those wealthy and highly cultured assimilated Jewish families who provided Klimt with most of his patrons and who indeed were the very backbone of Viennese culture during its brief and dazzling "golden age" between 1890 and the First World War.

This portrait met the fate of so many commissioned society portraits in failing to please the sitter. Two years after this portrait was painted, the king of society portraitists, John Singer Sargent gave up taking commissions of women, commenting bitterly that a portrait is just a picture of someone in which the mouth is "not quite right". Klimt was required to make alterations before he could collect his handsome fee of 5,000 guilders. Although this portrait is relatively restrained compared to many of Klimt's other paintings of the period, the highly-minded and intellectual Stonborough-Wittgenstein, may have been averse to Klimt's highly ornamented style. Later she would commission her famous philosopher brother Ludwig Wittgenstein to design for her a villa in a severe, functionalist style that consciously reacted to the Byzantine excesses of the Vienna Secession.

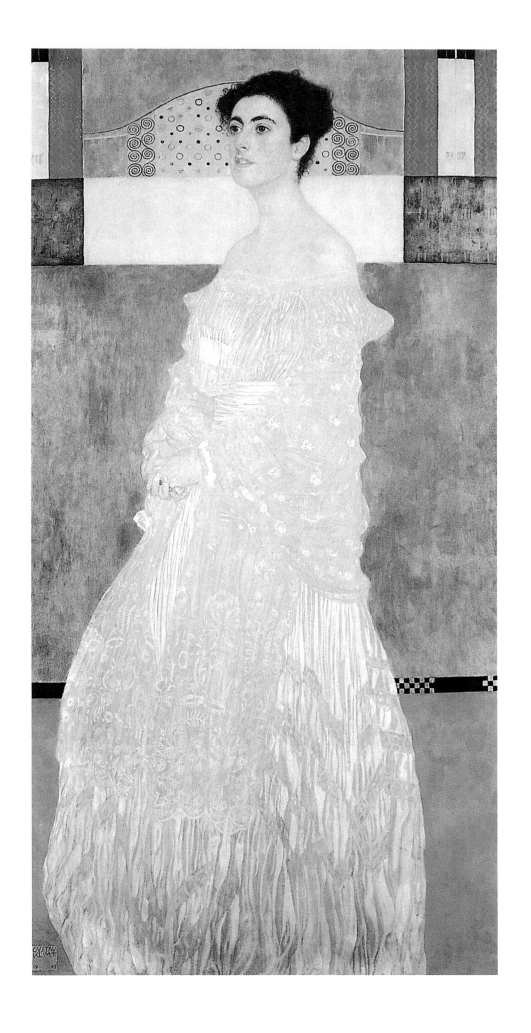

THE STOCLET FRIEZE

1905-1909
Oil on canvas
53.2 x 88 cm
Secession, Vienna

It is ironic that the most lavish and complete example of the Vienna Secession style survives not in Vienna itself but in a city associated with a very different kind of Art Nouveau. This is the so-called Palais Stoclet on the outskirts of Brussels, commissioned by the Belgian financier Adolphe Stoclet who had lived in Vienna and chose the Viennese architect Josef Hoffmann rather than Victor Horta, the local master of the curvilinear Belgian Art Nouveau style. Every element within the house, down to the cutlery that graced the dining table, was created by Viennese artists and designers associated with the Secession and the Wiener Wekstatte. For the dining room, Klimt designed a magnificent mosaic, executed by Leopold Forstner in precious metals, semi-precious stones, enamel and coral against a background of white marble.

The richly decorative mosaic relates to the Byzantine style of paintings such as *The Kiss* and the first *Portrait of Adele Bloch-Bauer*, painted around the same time. The theme of expectation and fulfilment once again shows Klimt's obsessive interest in human sexuality.

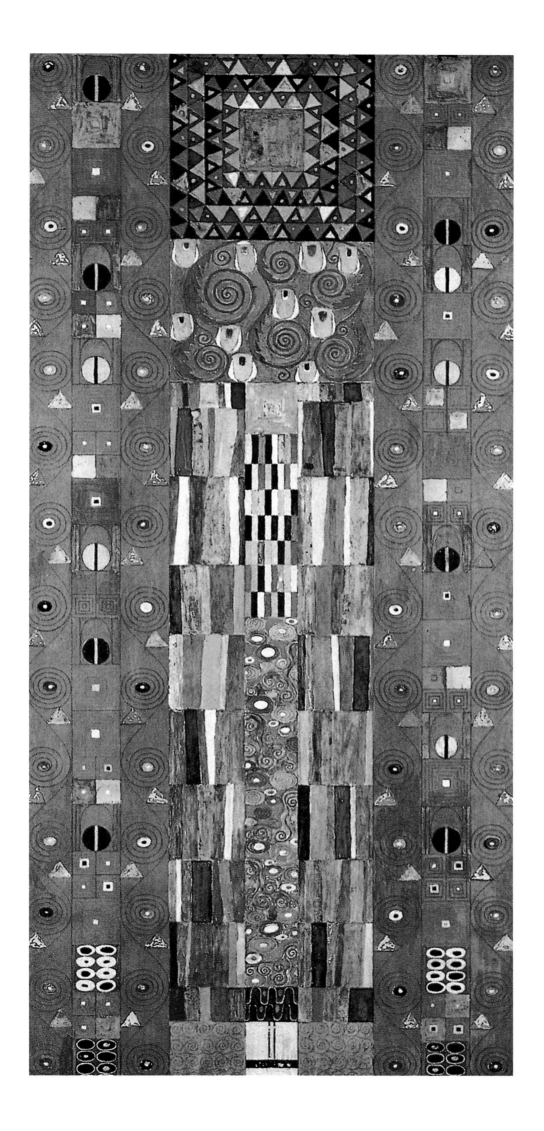

SUNFLOWERS GARDEN

c.1905-6
Oil on canvas
110 x 110 cm
Österreichische Galerie, Vienna

The all-over density of detail of this painting gives the impression that the painting is a section of a sumptuous wall-paper. The cropping of the plants and flowers on all four sides of the canvas implies that we are looking at a tiny fragment of nature that continues infinitely in all directions. In this painting that probably reflects the unkept profusion of Klimt's own garden, the artist wishes to celebrate the sheer fecundity of nature.

Van Gogh's paintings had been shown at the Secession in 1903 and by this time his paintings of Sunflowers were already legendary. Though Klimt undoubtedly knew them,

there is no indication from this painting that he paid much attention to them. Klimt's flowers are more purely decorative and less charged with subjective emotion than those of Van Gogh.

This picture was first shown at the 1908 Vienna *Kunstschau*, the exhibition that revealed the more abrasive talents of a younger generation of Viennese artists who certainly had paid attention to Van Gogh, which included Egon Schiele, Oskar Kokoschka and Richard Gerstl. In the company of these firebrands, Klimt himself was elevated to the status of a living old master.

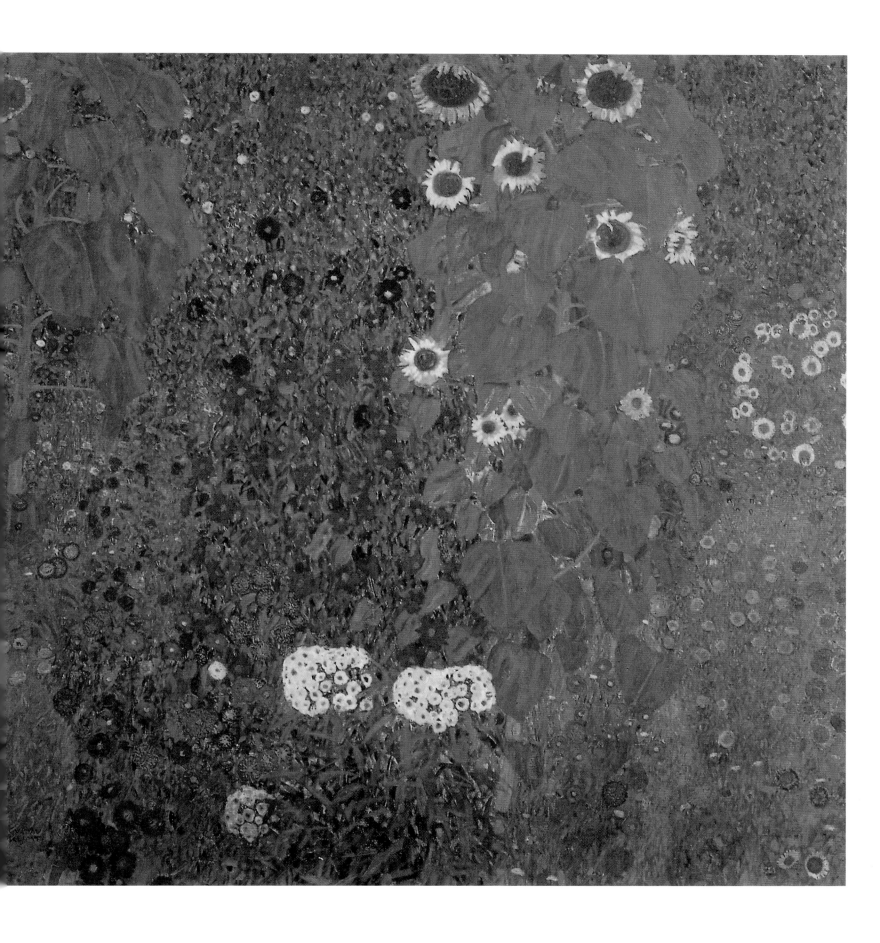

PORTRAIT OF FRITZA RIEDLER

1906
Oil on canvas
153 x 133 cm
Österreichische Galerie, Vienna

In his portrait of Fritza Riedler, Klimt further develops the deliberate tension between the naturalism and three dimensional depiction of the face and the hands and the surrounding flat and geometric decorative elements that seem to imprison the figure.

The elliptical "eye" motif, which may be seen as symbolically representing the female sex organ, would become a constant feature of Klimt's work over the next few years. The spatially ambiguous semi-circular mosaic panel behind Fritza Riedler's head draws attention to her face and also makes witty reference to the elaborate head-dresses of the Spanish Habsburg princesses in the famous Velázquez portraits in the Vienna History of Art museum. This portrait is yet another example of Klimt's creative and brilliant eclecticism. We have an unlikely but highly successful fusion of elements taken from Spanish Baroque painting, Byzantine mosaics, Japanese wood block prints and in some of the geometric decoration, ancient Greek art.

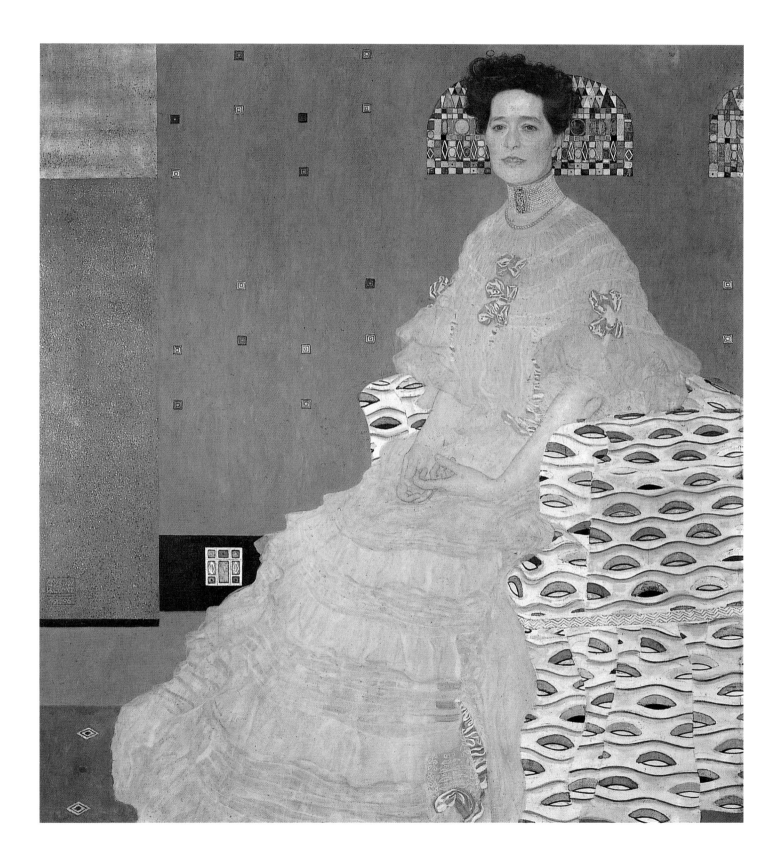

HOPE II

1907
Oil, gold and platinum on canvas
110.5 x 110.5 cm
Museum of Modern Art, New York

Klimt returned to the theme of pregnancy with *Hope II*, painted four years after the first version. This version is far less provocative than the 1903 version with its disturbing nudity and challenging stare. This time the bulge of the pregnant belly is decorously covered with a sumptuous fabric. The swollen version of the "eye" motif reinforces the theme of pregnancy and fertility. The mood is less gloomy though death is still present in the form of the half-hidden skull resting on the woman's stomach.

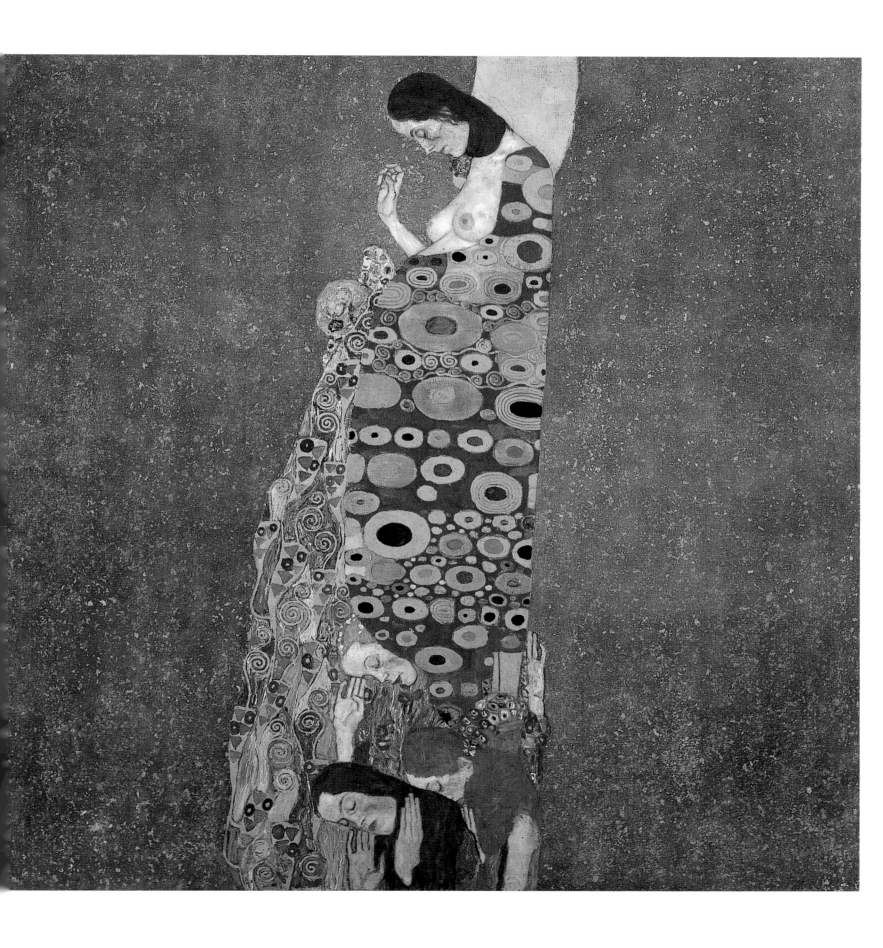

THE KISS

1907-1908
Oil on Canvas
180 x 180 cm
Österreichische Galerie, Vienna

Klimt's *The Kiss* of 1908, which has become his best-known picture, was preceded by two other famous versions of the subject by Rodin and Munch. All three show a pre-occupation with Eros and the troubled sexual relations between man and woman that was characteristic of the turn of the century's Western culture. Klimt's *Kiss* is less pessimistic and less misogynistic than Munch's puddle of melted human flesh and less pretentious than Rodin's heroically nude pair of marble lovers.

Of the three though, Klimt's image is the most explicitly sexual with its use of symbolic and erotically charged ornament. An enclosing "female" space is penetrated by the embracing lovers whose combined forms suggest that of an engorged phallus, the streams of gilded spermatazoa-like ornament flooding down to the lower right-hand side of the picture indicate that the moment of climactic ecstasy has just passed.

Despite Klimt's not so oblique treatment of a sexual theme, *The Kiss* with its sumptuously decorative qualities must have looked reassuringly beautiful beside the harshly expressionistic works of Schiele and Gerstl that were shown with it in the 1908 *Kunstschau*. For once Klimt's work was received with enthusiasm and it was bought directly from the exhibition by the Austrian state.

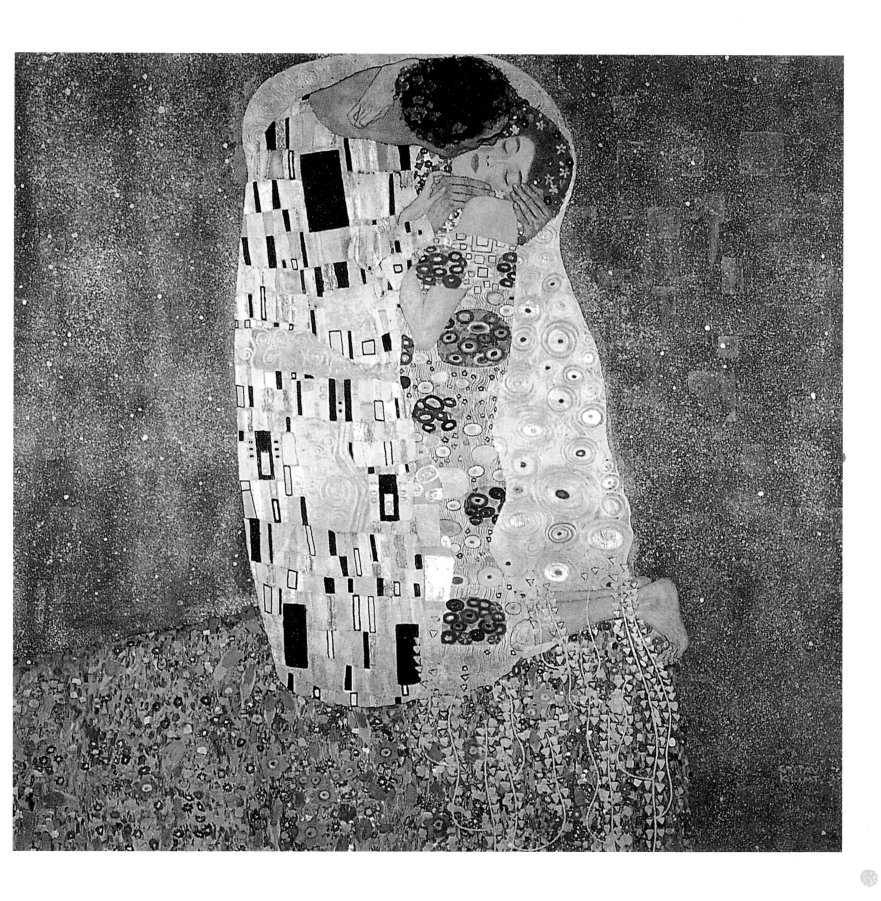

119.

PORTRAIT OF ADELE BLOCH-BAUER I

1907
Oil and gold on canvas
138 x 138 cm
Österreichische Galerie, Vienna

In 1903 on a trip to Ravenna, Klimt was greatly impressed by the famous early Christian mosaics in the churches of the city. The results of that interest were seen in his so-called Byzantine or Golden style that he developed over the next few years, using collage-like patterns of gold and silver ornament applied to the surface of the canvas. A tendency to flatness and abstraction had been common in much of Western avant-garde painting in the late nineteenth century from Manet and Rossetti onwards. What is unusual about Klimt's style is the combination of naturalistic elements with large areas of abstract geometrical ornament. Once again, much of this is symbolically and erotically charged and we find the vaginal "eye" motif repeated on Adele Bloch-Bauer's torso.

Bloch-Bauer's face and hands are imprisoned within a mass of golden ornament that takes up most of the picture surface. Her heavy lidded languor. Parted lips, claw-like hands and the way her bejewelled choker separates her head from her shoulders all create a somewhat sinister effect. It was inevitable that such an extreme picture would not find favour with everybody. The critic of the *Neues Wiener Tagblatt (a Viennese newspaper)* described it as *Mehr blech als Bloch* ("more rubbish than Bloch") and went on to say that Klimt was "master of an extraordinarily developed technique. And what does he use it for? In order to paint a mixture of peacock's tails, mother of pearl, silver scabs, tinsel and snail's paths".

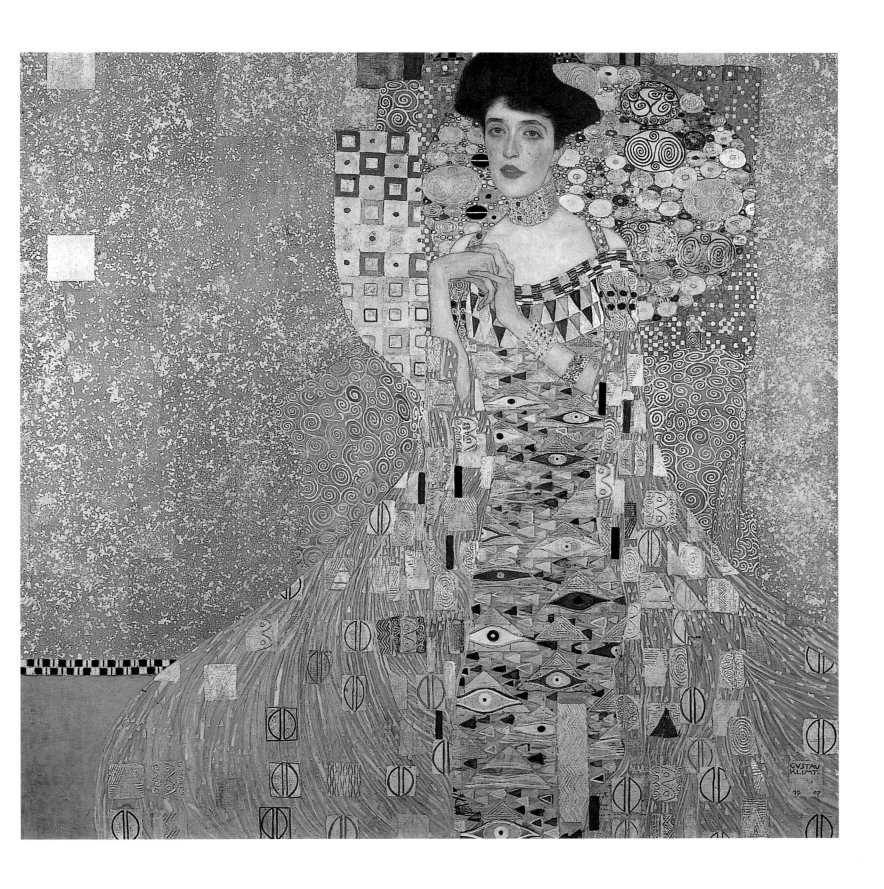

DANAE

1907-8
Oil on canvas
77 x 83 cm
Private collection

According to Greek mythology, Danae was the daughter of Acrisius, king of Argos. After an oracle predicted that Danae's son would kill him, Acrisius imprisoned her in a tower (or in some versions of the story, in a bronze underground chamber). The prophecy was fulfilled after Zeus visited Danae in the form of a golden shower and impregnated her with Perseus, who after he had grown to manhood, accidentally killed Acrisius with a discus. Danae was the subject of one of the most notoriously erotic paintings of the Italian Renaissance by Correggio. Even Correggio's version is surpassed in eroticism by Klimt's. As usual Klimt has exploited mythology merely in order to explore his favourite theme of female sexuality. There is an extraordinary sense of voyeuristic intimacy as we are brought close to the apparently sleeping form of Danae, curled up and claustrophobically confined by the shape of the canvas as she is impregnated by the shower of erotically charged golden ornament.

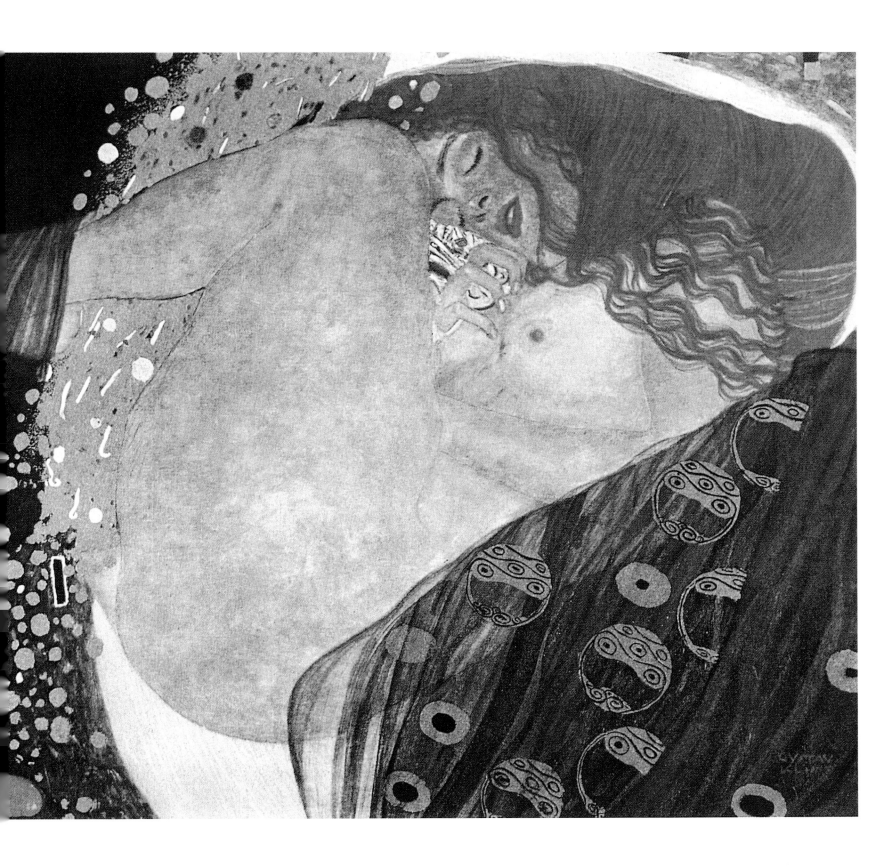

KAMMER CASTLE ON THE ATTERSEE I

c.1908
Oil on canvas
110 x 110 cm
Národní Gallery, Prague

While Klimt favoured unusual and elongated formats, (often vertical) for many of his figurative paintings, nearly all his landscapes are painted on canvases that form a perfect square rather than the traditional horizontal landscape format. In all his landscapes, Klimt is concerned with synthesis and with abstract pattern-making rather than with the faithful recording of natural appearances. Typically Klimt chooses a viewpoint that allows less than a complete view of the castle and its vast bulk appears to be flattened with no more than a thin strip of sky running along the top of the picture.

This picture was another of Klimt's works which show that Impressionists held no interest for him. His theme was the fecundity of nature and nature in all its most pleasurable aspects.

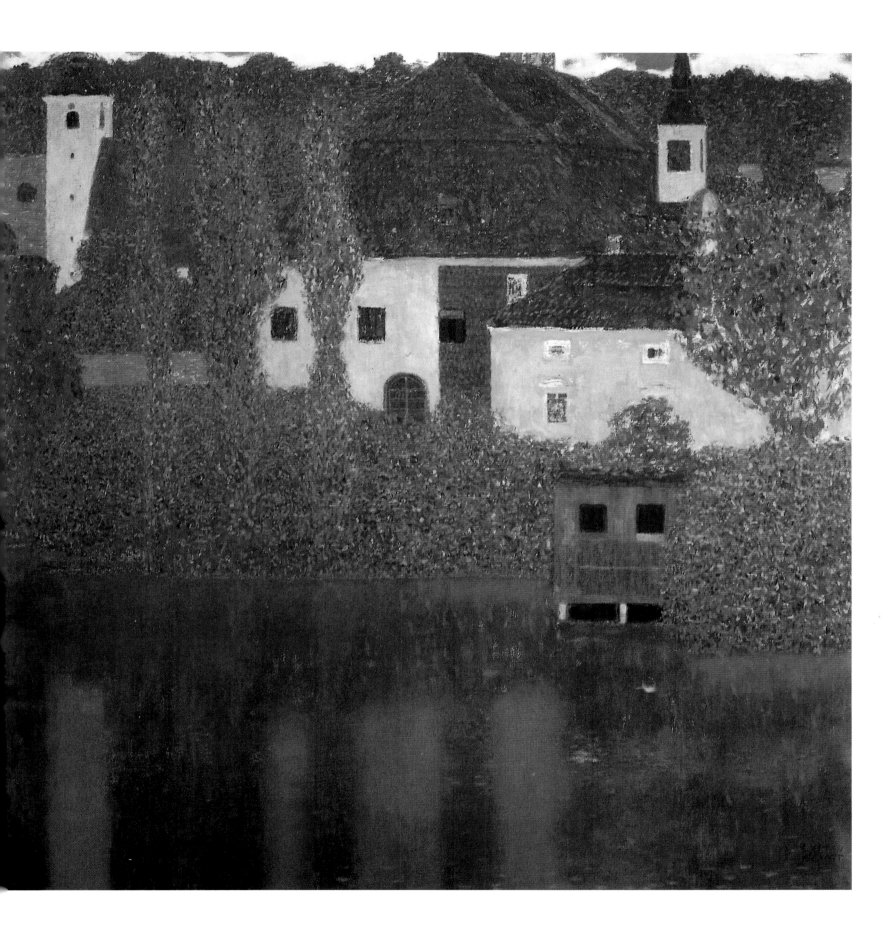

WOMAN WITH A HAT AND FEATHER BOA

1910
Oil on canvas
69 x 55.8 cm
Private collection

The most striking feature of this painting is the huge hat that fills the upper part of the picture and is cut off on the right hand side of the canvas. In the early nineteen hundreds, fashionable women often towered over their male companions, teetering on their high heels, padded and corseted with hair piled high and surmounted with the most outrageous hats. By 1910 this heavily upholstered look was slightly unfashionable by the latest Parisian standards. Under the influence of Leon Bakst's designs for Diaghilev's Ballets Russes, Parisian couturiers such as Paul Poiret had already moved on to turbaned heads and a more streamlined and natural profile for the body. In the *Woman with a Hat and Feather Boa* as in the *Lady with a Feather Hat* both dating from 1910, Klimt seems momentarily to have lost the *horror vancui (vanquished horror)* that characterises so much of his work. He would soon revert to richly decorated backgrounds, but for a short time at least he experimented with the empty backgrounds favoured by his younger contemporaries Schiele and Kokoschka.

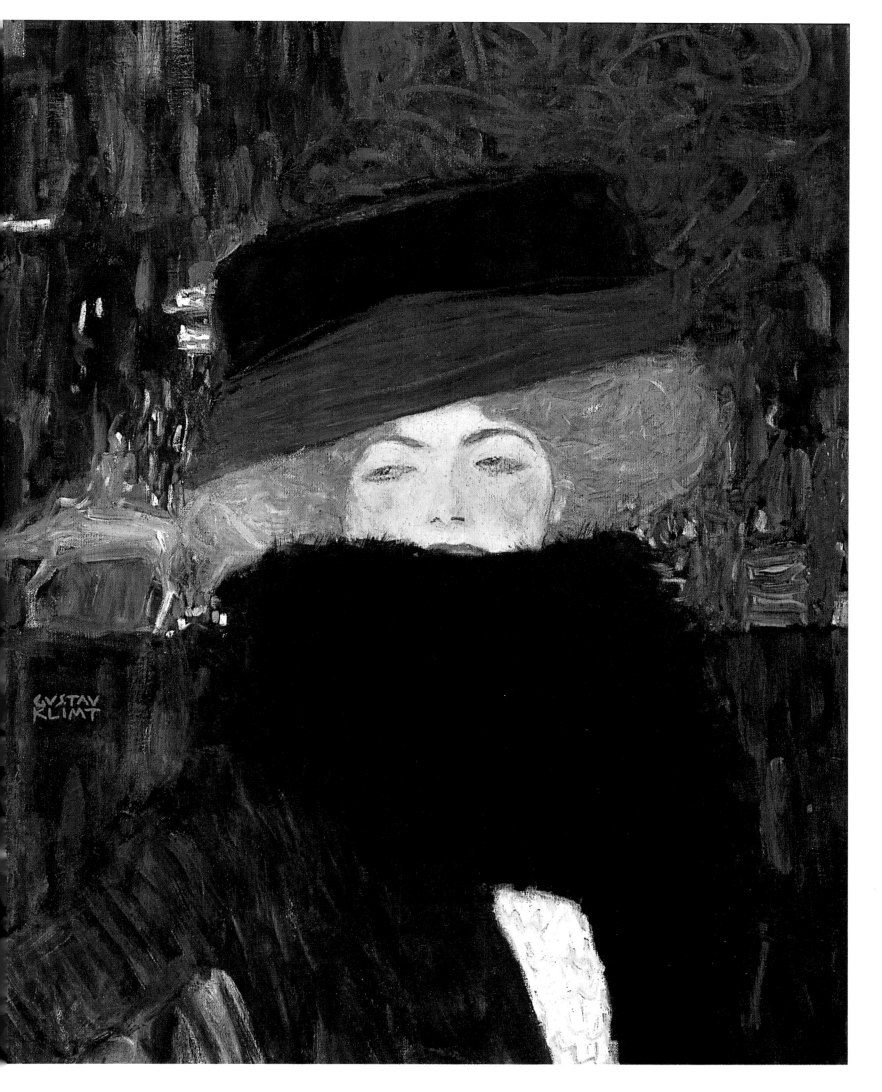

JUDITH II

1909
Oil on canvas
178 x 46 cm
Galleria Internazionale d'Arte Moderna
di Ca' Pesaro, Venice

Not altogether surprisingly, *Judith II* has often been mistitled as *Salome*. The undulating pose suggests the movements of a dancer and the gorgeously patterned fabrics could easily be Salome's seven veils. It was no doubt paintings such as this that prompted the composer Richard Strauss to make a comparison between Klimt's work and the coruscating score of his operatic masterpiece *Salome*. Indeed the meaning of the Salome and Judith stories was the same for many artists at the turn of the century. That meaning was made shockingly clear in a letter written by the Symbolist painter Gustave Moreau, who had depicted *Salome* with obsessive frequency.

"This bored and fantastic woman, with her animal nature, giving herself the pleasure of seeing her enemy struck down, not a particularly keen one for her because she is so weary of having all her desires satisfied... When I want to render these fine nuances, I do not find them in the subject, but in the nature of women in real life who seek unhealthy emotions and are too stupid even to understand the horror in the most appalling situations."

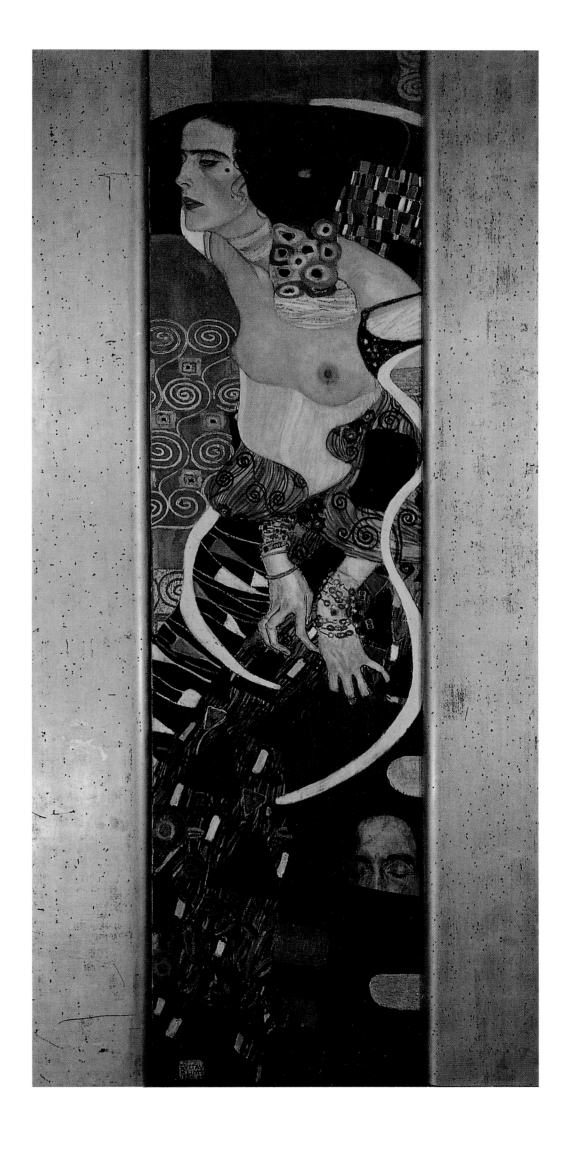

129.

BLACK FEATHER HAT (LADY WITH A FEATHER HAT)

1910
Oil on canvas
63 x 79 cm
Private collection

Around 1909-1910, Klimt moved on from his "Byzantine" style and abandoned the use of gold and silver. His brushwork became looser and bolder and his work showed an increased response to the remarkable developments in French painting over the previous four decades. The exhibitions of the Secession gave Klimt plenty of opportunity to study modern French painting at first hand. In particular the sixteenth exhibition of the Secession in 1903 presented the work of Manet, Degas, Pissarro, Monet, Renoir, Sisley, Cezanne, Gauguin, Van Gogh, Toulouse-Lautrec, Redon, Denis, Vuillard and Bonnard. Rather like his musical contemporary Puccini, Klimt was an eclectic capable of stealing whatever he needed from the most varied sources and making it his own. In the case of the *Woman with a Feather Hat*, it was perhaps Toulouse-Lautrec who had the most to offer him. The picture has a poster-like boldness of design. Klimt certainly knew of Lautrec's epoch-making poster of Aristide Bruant with a scarlet muffler cutting across Bruant's chin. As this picture was not a commissioned portrait, Klimt could afford to take a similar liberty with his sitter.

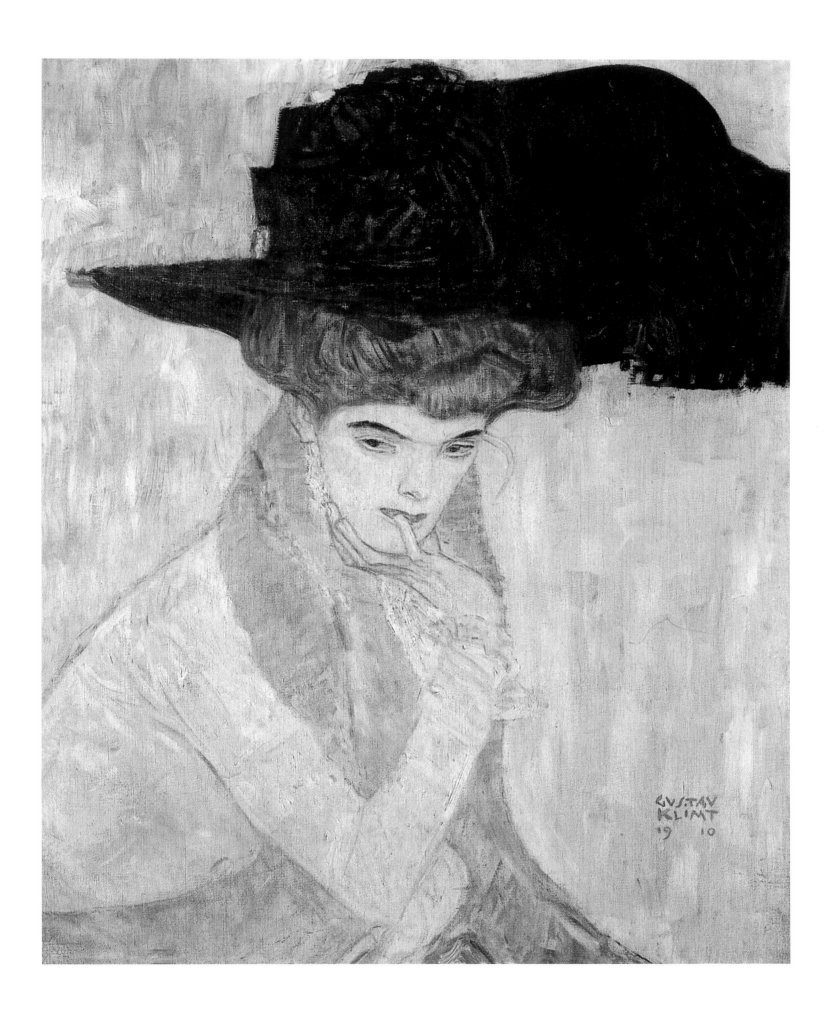

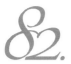

PORTRAIT OF ADELE BLOCH-BAUER II

1912
Oil on canvas
190 x 120 cm
Österreichische Galerie, Vienna

In 1912 Adele Bloch-Bauer returned to Klimt for a second portrait which in its way is just as spectacular as the first. We see here all the characteristics of Klimt's late portrait style. He has abandoned the use of applied gold and silver but not his love of ornament and his desire to flatten space. The looser, more painterly technique of broken brushwork and the brighter, fresher pallet of colours shows his study of French painting. The oriental figures in the background are also a feature of many of Klimt's later portraits. The influence of Japanese woodblock prints had been visible in Klimt's work from the 1890s, but over the years his interest widened to include many aspects of oriental art. He acquired the full run of Siegfried Bing's pioneering periodical *Le Japon Artistique (Artistic Japan)* and collected not only Japanese prints but also oriental ceramics and screens that he displayed in his studio at Hietzing. Motifs such as the oriental horsemen in the background of Adele Bloch-Bauer's portrait were often drawn from the decoration of ceramics.

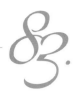

PORTRAIT OF MÄDA PRIMAVESI

c.1912
Oil on canvas
149.9 x 110.5 cm
The Metropolitan Museum of Art, New York

Klimt had a personal friendship with the Primavesi family and enjoyed their hospitality on many occasions at the estate near Olmutz in Moravia. The Primavesis were typical of the wealthy and cultured Viennese Jewish elite who supported Klimt throughout his career and especially after his split with conservative officialdom. Otto Primavesi was a banker who became the chief backer of the *Wiener Werkstätte* with which Klimt was also closely associated. Primavesi owned several paintings by Klimt and like August Lederer, commissioned portraits of both his wife and daughter. The portrait of Mäda Primavesi is exceptional amongst the commissioned portraits of Klimt in showing a young girl. Unlike his protégé Egon Schiele, Klimt was not particularly interested in the sexuality of children and adolescents. Nevertheless in Vienna after the publication of the theories of Freud about child sexuality, such things were certainly discussed in the circles frequented by Klimt. Klimt made a sheet of preparatory studies for this portrait that show diagonal lines converging obsessively on the area of the young girl's sex, a feature also apparent, if less blatantly so, in the final portrait. Standing with her legs wide apart and her arms behind her back as though hiding something, Mad Primavesi's gaze is at once confident, self-contained and challenging.

VIRGIN

1913
Oil on Canvas
190 x 200 cm
Národní Gallery, Prague

In Klimt's late style with bold colours and freer application of paint we see a motif that preoccupied the artist for many years, from the Vienna University ceilings onwards – a mass of floating and intertwined bodies. Here the bodies are all those of young women. The subject is hard to explain as there seems to be no clear symbolic program. The central figure is perhaps the virgin of the title, though her rapt expression and her outstretched arms suggest the awakening of sexual desire rather than virginal innocence. The patterned rendering of flowers is similar to that in Klimt's landscapes of the same period and the extensive use of the Mycenian scroll motif shows that Klimt had not lost his interest in ancient Greek ornament.

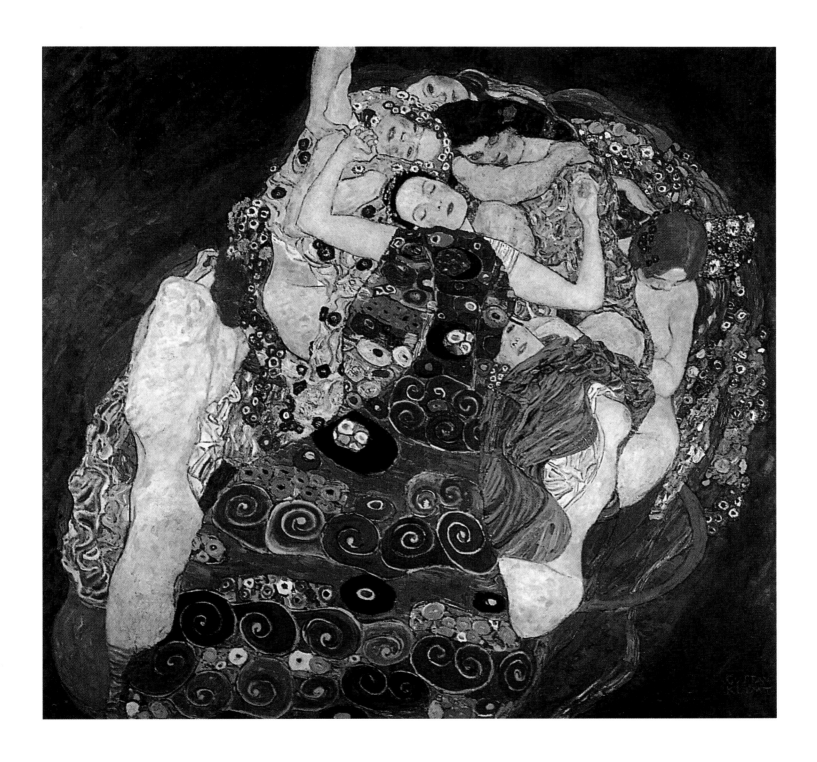

PORTRAIT OF ELISABETH BACHOFEN-ECHT

1914
Oil on canvas
59.8 x 84.2 cm
Private Collection

Baroness Elisabeth Bachofen-Echt was the daughter of Klimt's most important patron, the industrialist August Lederer. He generously loaned Klimt the 30,000 crowns needed to repay the advance he had received from University of Vienna in order to re-acquire his controversial ceilings. Lederer then bought the panel *Philosophy* from the artist.

With equal generosity of spirit, several years later, Klimt introduced his best patron to the young Egon Schiele who was commissioned to paint Lederer's son Erich and to give the young boy art lessons.

Baroness Elisabeth Bachofen-Echt was the second female member of the family painted by Klimt. He had already painted her mother Serena Lederer in 1899 and he would go on to paint her grandmother Charlotte Pulitzer in 1915. The portraits of Serena Lederer and her daughter are in stark contrast with one another. The mother's portrait is a delicate Whistlerian harmony in white, whereas the Baroness' portrait was painted in the riotous colours of Klimt's late manner. As in the portrait of Friederike Maria Beer and the second portrait of Adele Bloch-Bauer, the figures in the background are lifted from the decoration of oriental ceramics.

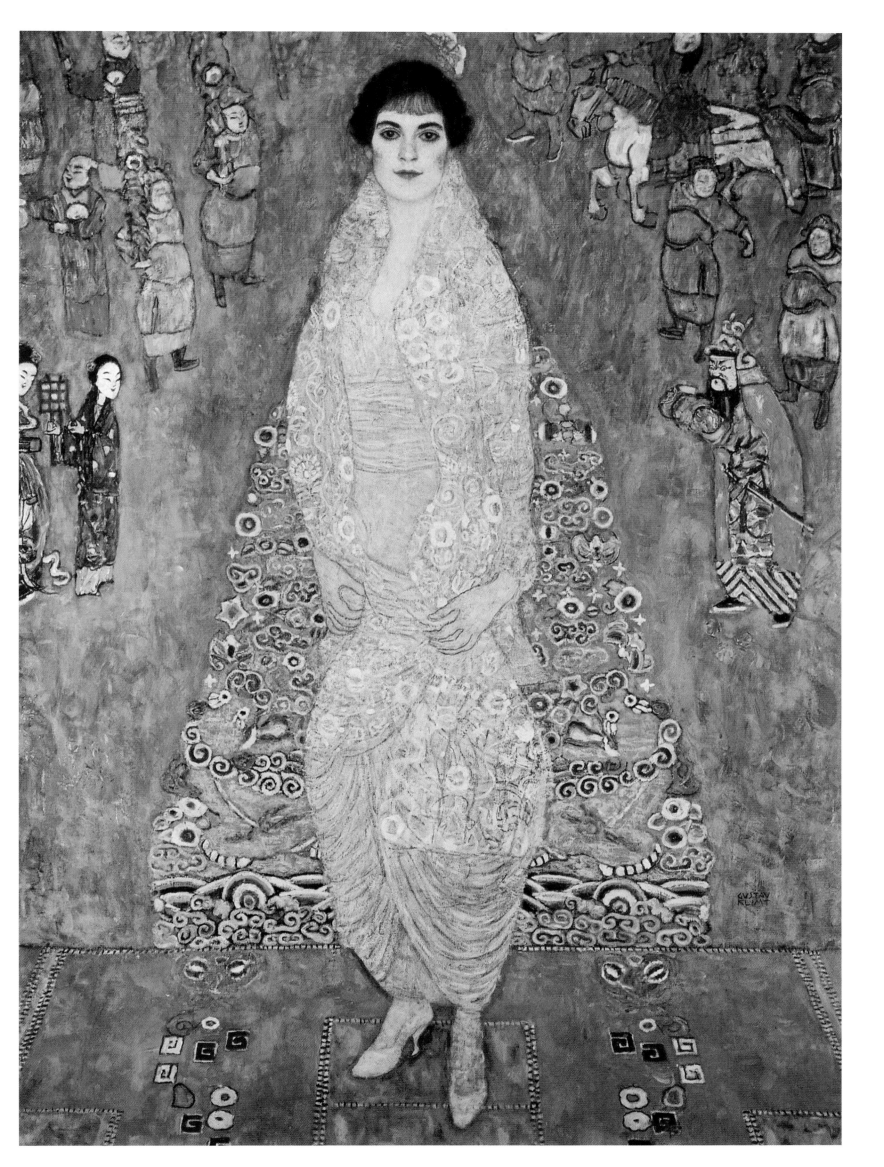

SEMI-NUDE LYING DOWN

1914
Blue pencil
37 x 56 cm
Historisches Museum, Vienna

Klimt went further than any previous artist in the exploration of female sexuality. Before Klimt, the subject of a woman masturbating would have been impossible to depict outside the realms of pornography. Indeed the very notion of woman taking pleasure in sex would have been an anathema to many conservative bourgeois of Klimt's day. That Klimt dealt so obsessively with the theme of female sexuality no doubt reflects his own tastes and inclinations but also the preoccupations common to many artists and intellectuals of his day. Amongst the artists who were exploring the same territory, even if they did not all travel as far as Klimt, were Degas, Rops, Munch and Beardsley. It can be no coincidence that Sigmund Freud was attempting to explore and explain human sexuality with new directness and honesty in Vienna at the same time. Freud's writings achieved very limited circulation at the time and it is hard to imagine Klimt sitting down to read *The Interpretation of Dreams*. But many of Klimt's cultured and intellectual Jewish patrons would have been familiar with Freud's ideas, and given Klimt's interests, must have discussed them with the artist. It could also be said that both Freud and Klimt, even if they were not greatly familiar with one another's work, were products of the same culture and the same set of influence in the Vienna of 1900. Despite their highly explicit eroticism, Klimt's superb drawing of the woman masturbating goes far beyond mere pornography.

PORTRAIT OF FRIEDERIKE MARIA BEER

1916
Oil on canvas
168 x 130 cm
Private collection

The youthful, pleasure-loving and cultured Friederike Maria Beer was the only woman in Vienna with the wealth and the good taste to commission both Klimt and Egon Schiele to paint major portraits of her, thus providing a unique point of comparison between the two great Viennese painters. The portrait by the young Schiele dates from 1914 and that of the older Klimt came two years later. Friederike Maria Beer's plump and placid comeliness challenged both artists to make interesting and characteristic pictures. She was neither fatal nor neurotic. Schiele imposed some of his own anorexic nervosity on the healthy young woman. He placed her stretched out on the floor. Seen from above, she is surrounded by emptiness and seems to flail against her fate. To judge from contemporary photographs, Klimt's portrait is more faithful to her personality and physical appearance. He solved the problem of making her slightly bovine calm, and in surrounding her with battling figures, lifted from an oriental vase in the artist's collection. The characteristic flattening and compression of space makes it look as if their swords and lances are plunging into the body of the unconcerned young woman. Klimt's "vanquished horror" could not be more different from the minimalist background of Schiele's portait.

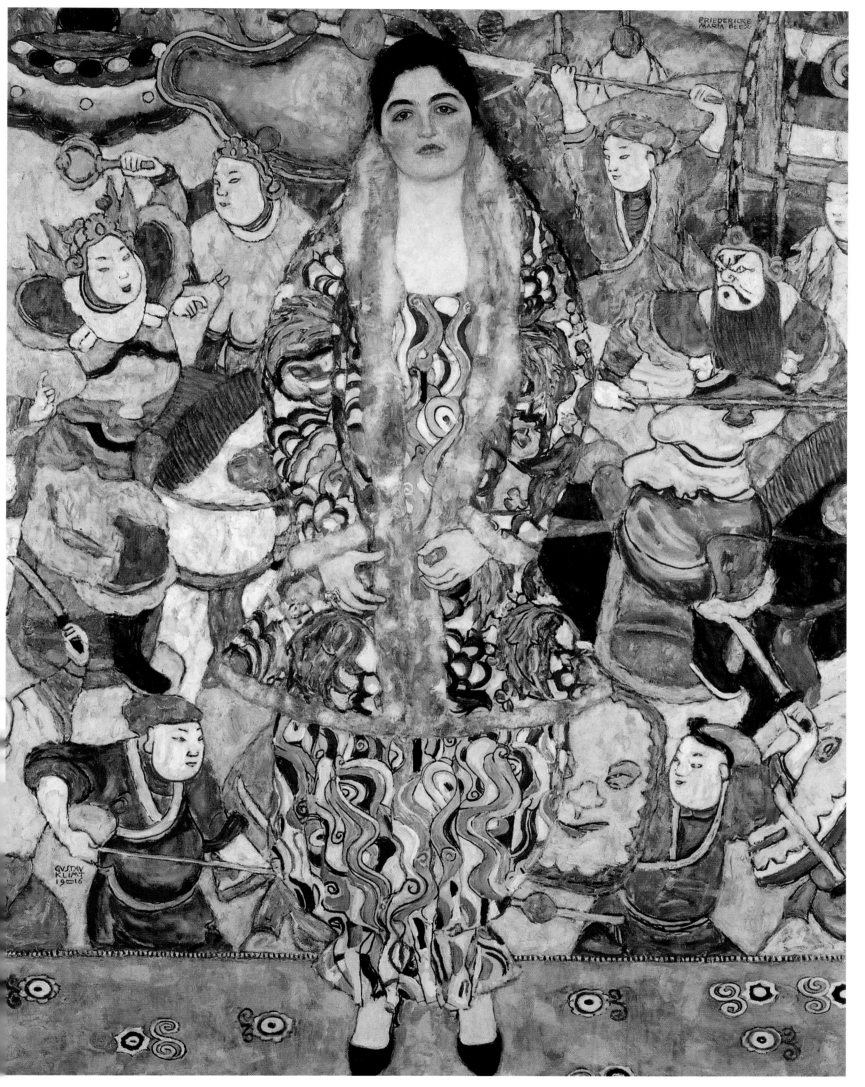

143.

DEATH AND LIFE

1911, reworked 1916
Oil on canvas
178 x 198 cm
Private collection

Artists of the Symbolist period had a penchant for pompously titled canvases on great universal themes. George Frederick Watts' *Love and Death*, Gauguin's *Where do we come from? What are we? Where are we going to?* Stuck's *Sin* and Munch's, *Frieze of Life* are all examples of this. In such a gorgeously decorative work, it is hard to take Klimt's philosophising very seriously. The skeleton draped in a sombre robe decorated with crosses provides a disappointingly banal image, but the floating group of sleeping figures on the right shows no diminution of Klimt's skills as a painter. As in other works where he depicts both male and female nudes, Klimt follows the academic practice (so much derided by Renoir) of differentiating between the skin colour of male and female figures.

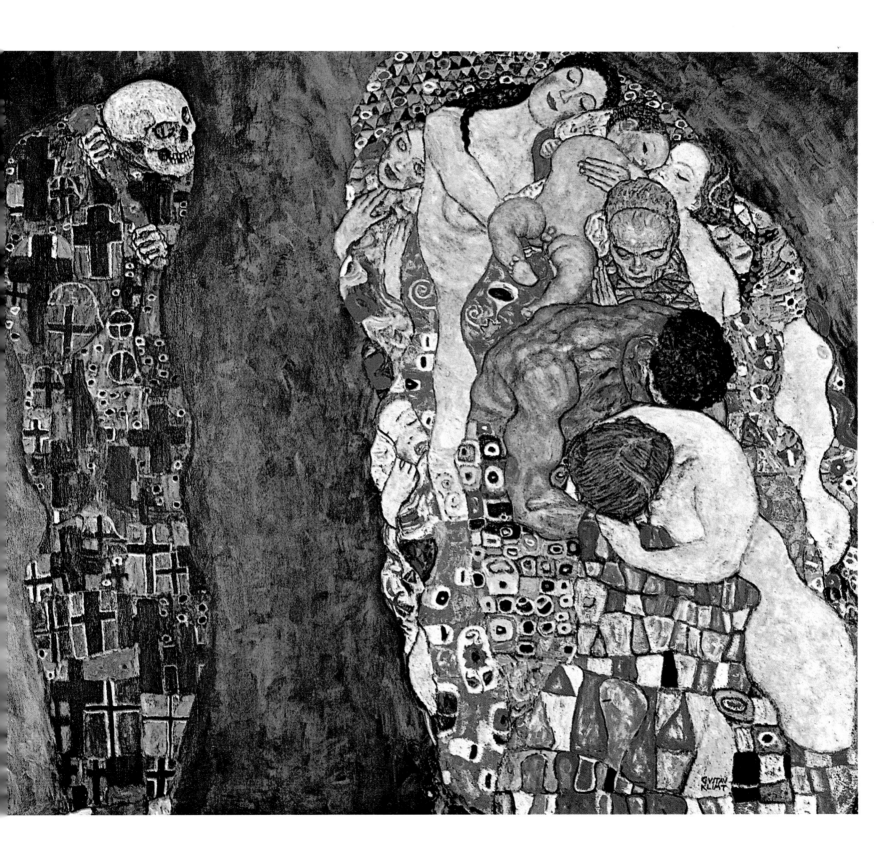

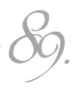

GIRLFRIENDS

1916-17
Oil on canvas
99 x 99 cm
Burned in Immendorf Castle 1945

The appearance of this beautiful late work was luckily preserved in a colour photograph before it was destroyed in 1945. Though it is a fantasy, rather than a commissioned portrait. It has much in common with the portraits of Friederike Maria Beer and Baroness Elisabeth Bachofen-Echt in the use of oriental motifs in the background.

As with several of Klimt's paintings such as *Water Snakes I* and *II* and *Goldfish* there is more than a hint of lesbianism in *The Girlfriends*. Lesbianism had been a fashionable theme with French writers and artists since the time of Baudelaire and Theophile Gautier and fitted in with Klimt's no-hold-barred exploration of female sexuality.

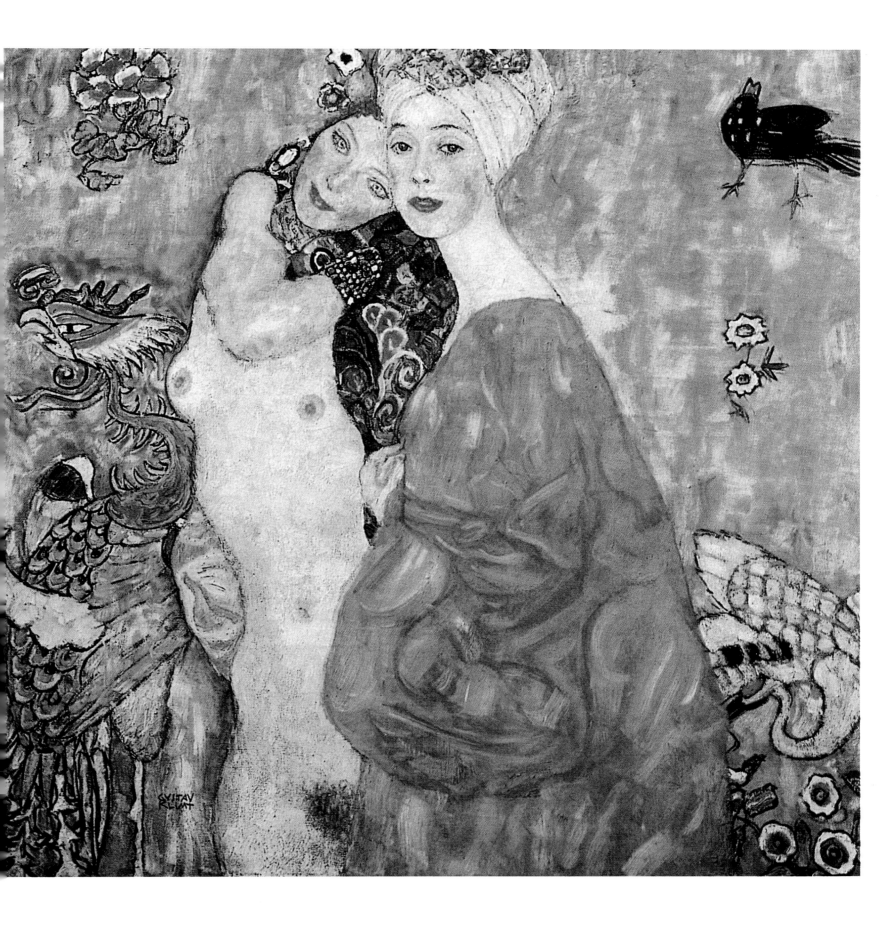

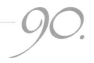

ADAM AND EVE, (UNFINISHED)

1917-18
Oil on canvas
173 x 60 cm
Õsterreichische Galerie, Vienna

Left unfinished at the time of his death, this painting perhaps best suggests the direction in which Klimt might have gone had he lived on into the inter war period. The large, simple volumes of the female nude have a sculptural quality. Like many artists at the end of the First world War, from Picasso and Matisse to Leger and Maillol, Klimt may have been interested in a return to a modern form of classicism and to a calmer and more monumental style. The title of *Adam and Eve* has been chosen to emphasise the primal and universal meaning of this depiction of love between a man and woman. The picture is certainly not in any way an illustration of the Biblical story. The plump blonde Eve with her happy and uncomplicated smile is reminiscent more of the phlegmatic Friederike Maria Beer, than of the *fin de siècle* allures of Adele Bloch-Bauer, suggesting that Klimt's attitude to women may have been in the process of changing as well.

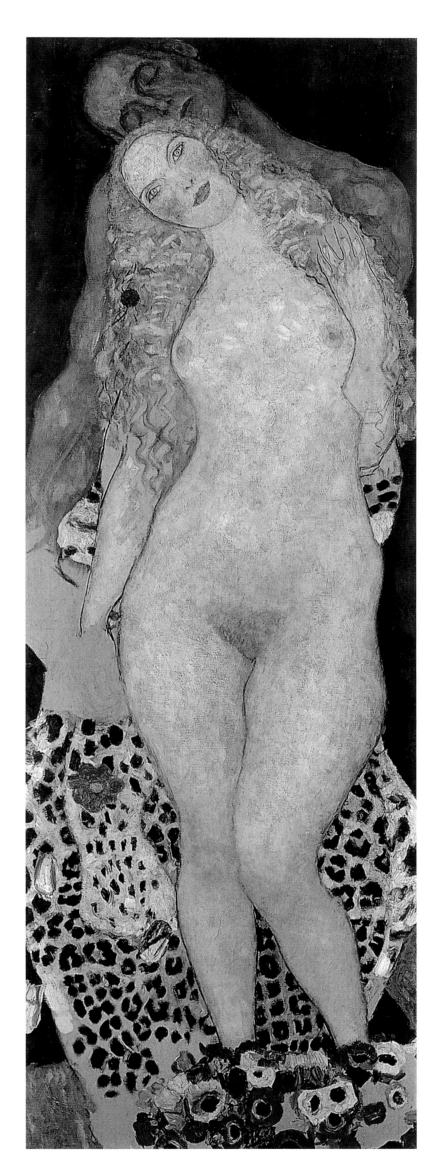

THE DANCER

c.1916-18
Oil on canvas
180 x 90 cm
National Gallery of Canada, Ottawa

When he died, Klimt was in the process of transforming this picture from a commissioned portrait that had been rejected by the sitter into something more personal. Once again, it is a picture that hints at new directions in Klimt's work.

The years immediately preceding the First World War saw an unprecedented acceleration of *avant-garde* tendencies in Western art. The Cubist revolution initiated by Picasso and Braque spread rapidly through the Western World with numerous cutting edge movements including Futurism, Orphism, Contructivism and Vorticism spinning off in all directions. Though Vienna itself was not greatly affected Klimt would only have to have travelled as far as Munich to see some of the most daring experiments of the period. The shifting and tilted perspectives in the lower half of this picture are perhaps the only indications that Klimt might have picked up on some aspects of cubism, had he lived longer.

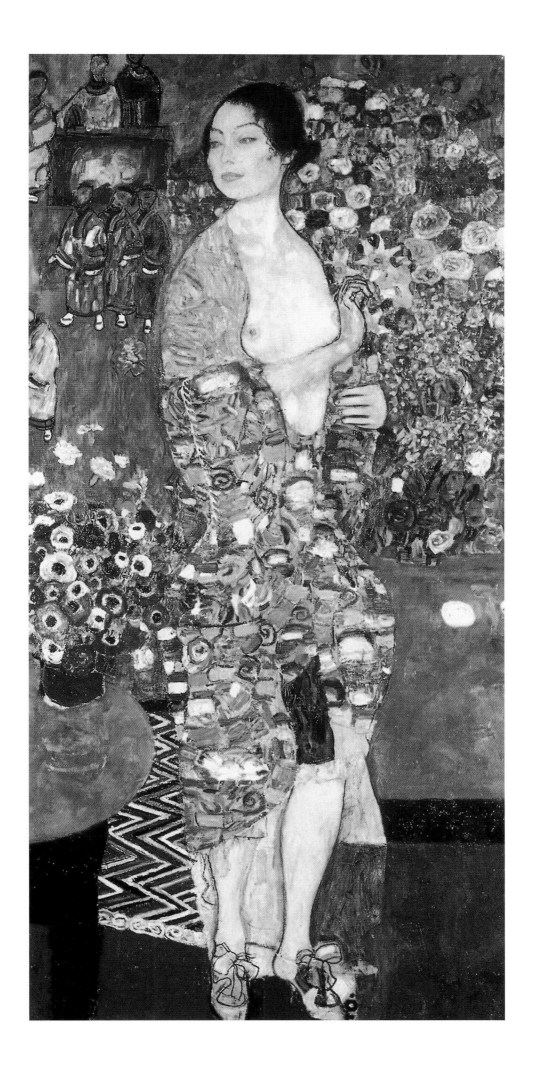

THE BRIDE

1917-18
Oil on canvas
165 x 191 cm
Private collection

In January 1918 as the First World War was entering its final bitter year, the fifty-five year old Klimt was stopped by a stroke. A few weeks later he died in hospital of pneumonia. At the time he died, Klimt was working simultaneously on a large number of paintings. These unfinished canvases are extraordinarily revealing of his working methods. We see that unlike the Old Masters, he worked directly on a bare canvas without the benefit of underpaint. We can also see that he worked section by section, beginning with the faces, that are sometimes completed before surrounding sections are even begun. *The Bride* reveals a secret that can also be divided from some of Klimt's preparatory drawings – that beneath their gorgeous clothing, Klimt envisaged his female figures nude and in full anatomical detail, including pubic hair.

Perhaps in reaction to the horrors of the war or perhaps just reflecting his own changing attitudes, *The Bride* like other late paintings depicts sex in purely celebratory terms and without the dark and menacing qualities of much of his earlier work.

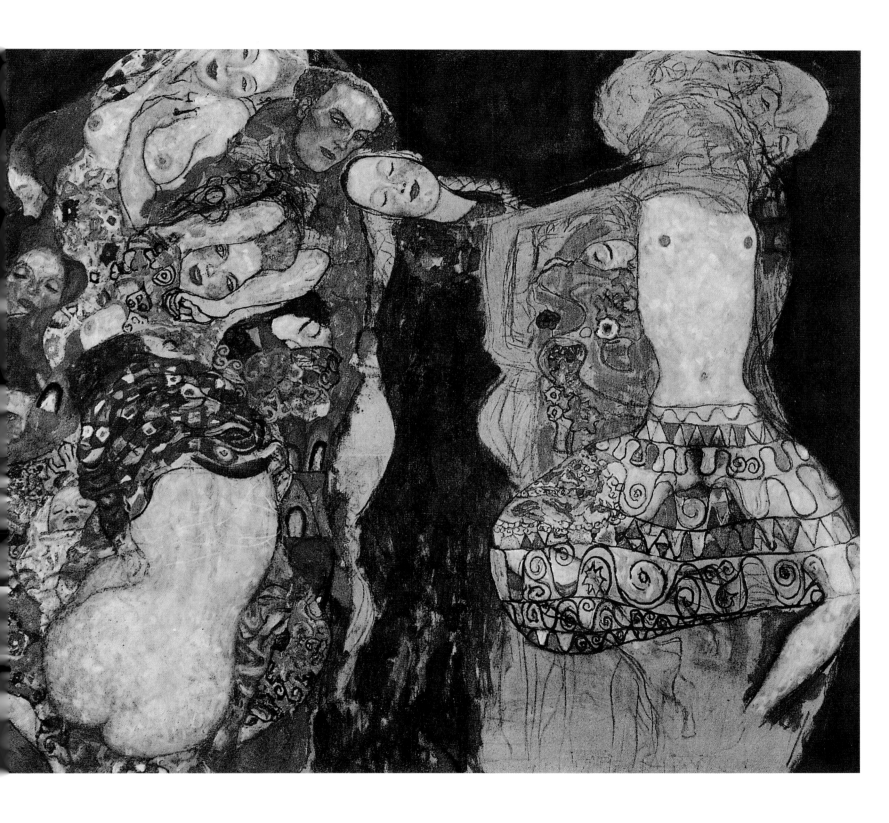

Klimt 1862-1918: Biography

1862
Birth of Gustav Klimt in Baumgarten, near Vienna. His father, Ernst Klimt was a gold engraver and his mother, Anna Finster, was a lyric singer.

1876
He enters The School of Arts and Sciences at the Museum of Art and Industry in Vienna. He takes painting classes with Professor Laufberger.

1877
To make money, he takes photographic portraits.

1883
Klimt gets his degree from The School of Arts and Sciences in Vienna. He opens a workshop with one of his brothers (Ernst Klimt) and another painter (Franz Matsch). They create several works together, some of which are frescos for theatres.

1885
The group decorates the Hermes villa and the National Theatre of Fiume.

1887
The Municipal Council of Vienna asks Klimt to paint an interior scene in the ancient imperial theatre.

1888
Klimt completes the painting in the Imperial Theatre. He receives the Golden Cross of Merit.

1889
Klimt begins the decoration of the staircases at the Museum of Art History in Vienna. He receives the Imperial Prize, awarded for the first time to him.

1890
Klimt becomes a member of the Group of Artists in the Plastic Arts in Vienna. With his brother Ernst and Franz Matsch, he is awarded "the highest recognition" for the decoration of the Museum of Art History.

1892
His father and his brother Ernst die.

1893
Klimt takes a trip to Hungary where Duke Esterhazy asks him to paint the Totis theatre.

1894
The Minister of Education asks Klimt and Matsch to do the Faculty Paintings on the ceiling of the hallway in the University of Vienna.

1897
Klimt leaves the Association of Artists in the Plastic Arts in Vienna. Joseph Maria Olbrich, Josef Hoffmann and Klimt found the Vienna Secession and Klimt becomes the Secession's president. Olbrich, Hoffman and Klimt work on the paintings Philosophy and Medicine for the University.

1898
First exposition of the Vienna Secession and the founding of its magazine: *Ver Sacrum*. The same year, Klimt becomes a member of the International Society of Painters, Sculptors and Engravers in London and is nominated a corresponding member of the Munich Succession.

1899
He finishes the decoration for the Music Room at the Dumba palace with his paintings *Schubert at the Piano* and *Music*.

1900
He exhibits, next to landscape paintings, his unfinished *Philosophy* in the Secession's house and the painting provokes violent protests. However, he receives a gold medal for this painting at the World Exhibition in Paris.

1901
The exhibition of *Medicine* receives criticism from the press.

1902
The Secession has an exhibition with a presentation of the *Beethoven Frieze*.

1903
A collective exhibition at the Secession with eighty works by Klimt. Klimt takes a trip to Ravenna and Florence.

1905
The order for the Faculty Paintings is cancelled and then bought back. Klimt retires from the Secession and leaves for Berlin where he participates in the Alliance of German Artists Exhibition with fifteen paintings and receives the "Villa Romana" Prize.

1906
Foundation of the Alliance of Austrian Artists (Klimt becomes president of the Alliance in 1912). He becomes an honorary member of the Royal Bavarian Academy of Decorative Arts in Munich.

1907
He finishes the Faculty Paintings and exhibits them in Vienna and Berlin.

1910
He participates in the Venice Biennial.

1911
Participates, with eight paintings, at the International Exhibition of Art in Rome and receives the first prize for *Life and Death*.

1912
Klimt becomes president of the Alliance of Austrian Artists in Rome.

1917
Klimt becomes an honorary member of the Academy of Decorative Arts in Vienna after a chair had been refused four times by the minister.

1918
On January 11th, Klimt suffers a stroke in his Viennese apartment and dies on February 6th, leaving a number of unfinished works.

Klimt 1862-1918: Index of Works

Page 81

Poster for the first exhibition of the Vienna Secession, 1898.
Lithography, 62 x 43 cm, private collection.

Page 83

Nuda Veritas, 1899. Oil on canvas, 252 x 56.2 cm,
Theatersammlung der Nationalbibliothek, Vienna.

Page 85

Schubert at the Piano, 1899. Oil on canvas, 200 x 150 cm,
Burned in Schloß Immendorf, Austria, 1945.

Page 87

The Beethoven Frieze, 1902. Casein on plaster, H. 220 cm,
Secession, Vienna.

Page 89

Two Lovers, 1901-1902. Study for the *Beethoven Frieze,*
Black pencil, 45 x 30.8 cm, Vienna.

Page 91

Island in the Attersee, c.1901.
Oil on canvas, 100 x 100 cm, private collection.

Page 93

Goldfish, 1901-1902. Oil on canvas, 181 x 66.5 cm,
Galleria Internazionale d'Arte Moderna.

Page 95

Judith I, 1901. Oil on canvas, 84 x 42 cm,
Österreichische Galerie, Vienna.

Page 97

Portrait of Emilie Flöge, 1902. Oil on canvas, 181 x 84 cm,
Historisches Museum, Vienna.

Page 99

Forest of Beech Trees I, c.1902.
Oil on canvas, 100 x 100 cm, Moderne Galerie, Dresden.

Page 101

Hope I, 1903. Oil on canvas, 189 x 67 cm,
National Gallery of Canada, Ottawa.

Page 103

Water Snakes I, 1904-1907. Watercolour, 50 x 20 cm,
Österreichische Galerie, Vienna.

Page 105

Water Snakes II, 1904-1907.
Oil on canvas, 80 x 145 cm, private collection.

Page 107

The Three Ages of Woman, 1905. Oil on canvas, 178 x 198 cm,
Galleria Nazionale d'Arte Moderna, Rome.

Page 109

Portrait of Margaret Stonborough-Wittgenstein, 1905.
Oil on canvas, 180 x 90 cm, Neue Pinakothek, Munich.

Page 111

The Stoclet Frieze, 1905-1909. Oil on canvas, 53.2 x 88 cm.

Page 113

Sunflowers garden, c. 1905-1906. Oil on canvas, 110 x 110 cm,
Österreichische Galerie, Vienna.

Page 115

Portrait of Fritza Riedler, 1906. Oil on canvas, 153 x 133 cm,
Österreichische Galerie, Vienna.

Page 117

Hope II, 1907. Oil, gold and platinum on canvas,
110.5 x 110.5 cm, Museum of Modern Art, New York.

Gustav Klimt

£9.99